THE WAY OF ART

INNER VISION • OUTER EXPRESSION

VOLUME TWO

BY

KELLY FEARING

EMMA LEA MAYTON

REBECCA BROOKS

W. S. BENSON AND COMPANY, INC.
AUSTIN, TEXAS

TABLE OF CONTENTS

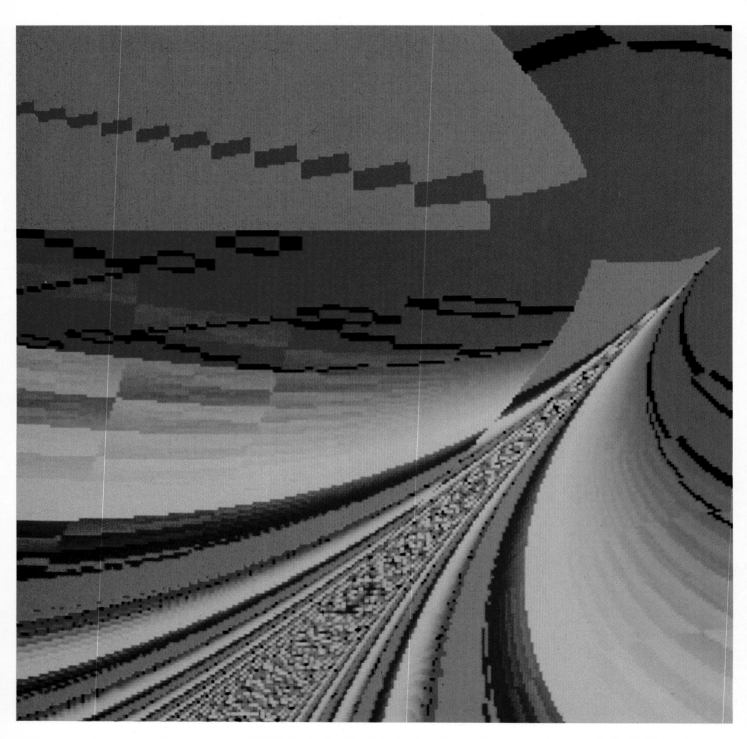

Computer art uses a television screen or CRT (Cathode Ray Tube) to display shapes, lines, and colors. Credit: Dr. H. W. Franke and Horst Helbig — Peter Arnold, Inc.

INTRODUCTION

In the first volume of this book, *The Way of Art*, you were introduced to the basic elements of art and the principles of design. You learned that all serious artists, past and present, used these elements and principles to change what they saw into works of art. You are now ready to expand your vision with new ideas and learn new skills and techniques. Looking out at the world around you, you will find that ideas come from every possible source. You will also discover ideas that come from the world within you. Ideas come from your imagination and dreams. Ideas for art also come from the legends and myths of many places and times.

You are ready to learn to draw what you want and in ways that are satisfying to you. Ideas can come from the environment, the human figure and from buildings. Even the world of technology can give you ideas for art.

You will explore further the elements, such as *color, texture,* and *line,* and learn to use them in your work.

You will find that art goes far beyond the classroom. Art is part of your life and community. You may even want to make art your career.

CHAPTER I
SEEING ART ELEMENTS AND DESIGN PRINCIPLES: A FOLIO

The elements of art—line, color, texture, shape/form, value, and space—are the ingredients of art. With them, all artists give form to their ideas, no matter what the content of their work. Although each artist has a different style, works of art are created with line, color, value, texture, shape and space. The work must also fit within space—the space of a sheet of paper, a canvas, or a wall. On flat surfaces the illusion of deep space may be created. The artist may also choose to leave the space flat, broken up only with shapes. If the work is sculptural or architectural, real space is used to contain the work.

What makes the work of some artists lasting and great? It is the quality which the artist has been able to put into the work that is important. To be able to see quality in works of art takes time and experience. There are experts in art who seem to have been born with "a good eye", so to speak. In the end, what makes art great cannot be totally explained with words. With much looking, you too, may come to *see* the greatness and timelessness in works of art. Throughout this book there are reproductions of works of art from both the past and the present. They have been chosen to show you how artists use the ingredients of art and arrange their ideas. In using the principles of design in a personal manner, each artist creates his or her *own way of art*.

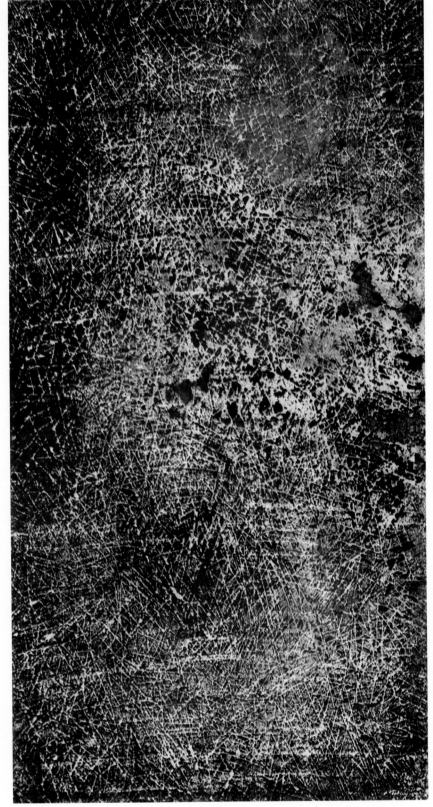

Mark Toby. *Untitled*. 1959. Gouache on paper, 19" x 28". James and Mari Michener Collection, The Archer M. Huntington Art Gallery, The University of Texas at Austin. Through a seemingly endless *repetition* of light lines on a dark background, Mark Toby has achieved an overall structure of *unity*. Note how he has used *variety* by changing the directions, the width, and spaces between the white markings. He has added *contrast* with the warm colored shapes placed on top.

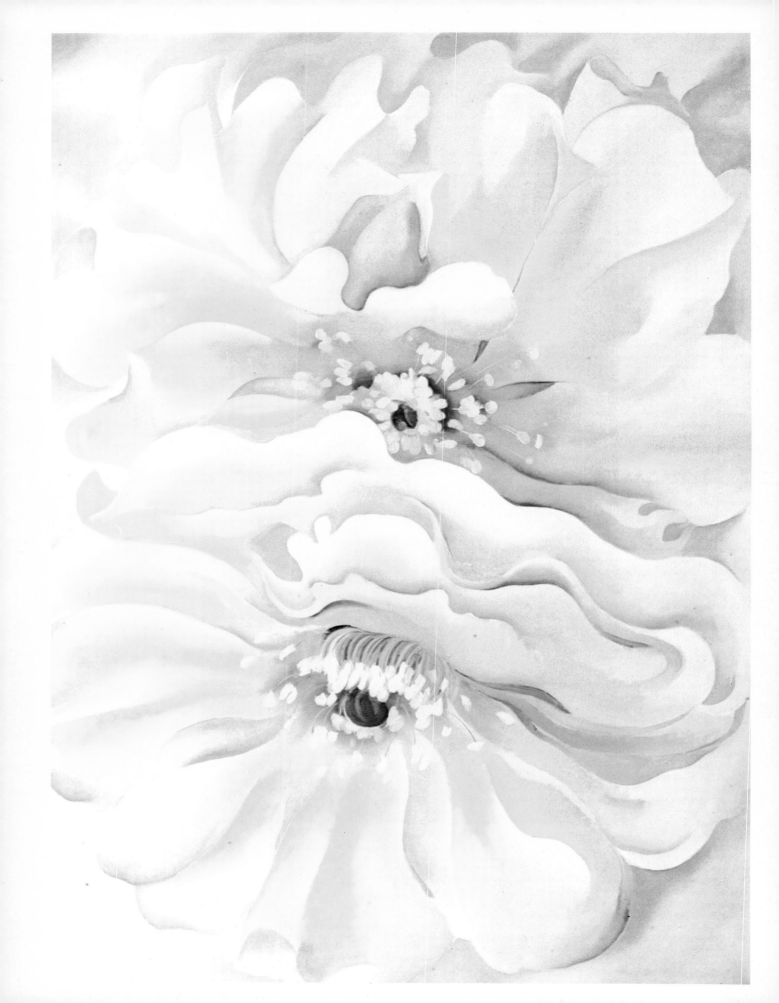

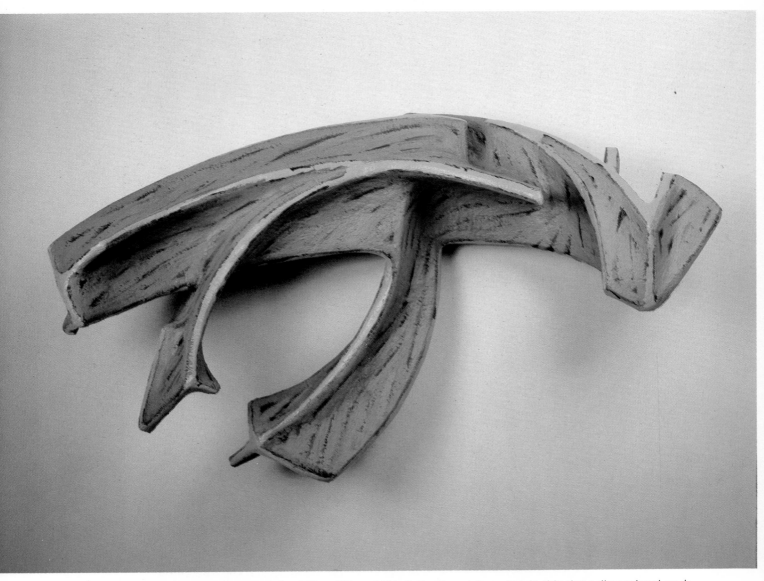

Edward C. Flood. *Sapon.* 1983. Mixed media, 38"h x 58"w x 24"d. Collection of the artist. In this three dimensional work Edward Flood has used a monochromatic color scheme of *contrasting* values to *emphasize lines*. The dark shadows repeating the *movement* in the work add *variety* and mystery. left: Georgia O'Keeffe. *Yellow Cactus Flowers.* 1929. Oil on canvas, 41½" x 29½". The Fort Worth Art Museum, William E. Scott Collection. When Georgia O'Keeffe brings us close to flowers our eyes focus on the *repeated shapes* of the petals with their rhythms and variations. The *contrasts* between the centers of each flower gives further *variety* to the painting.

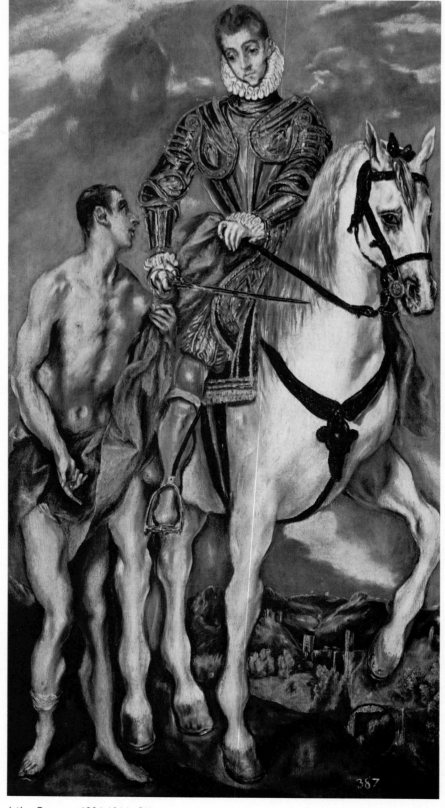

El Greco. *Saint Martin and the Beggar.* 1604-1614. Oil on canvas, 41" x 23⅝". The National Gallery of Art, Washington, D.C., Andrew W. Mellon Collection. El Greco, a painter in 16th-century Spain, was concerned with portraying human emotions and feelings of compassion. He achieved this aim through his unique way of exaggerating the human form and gave emphasis through his personal use of color and writhing dark and light patterns.

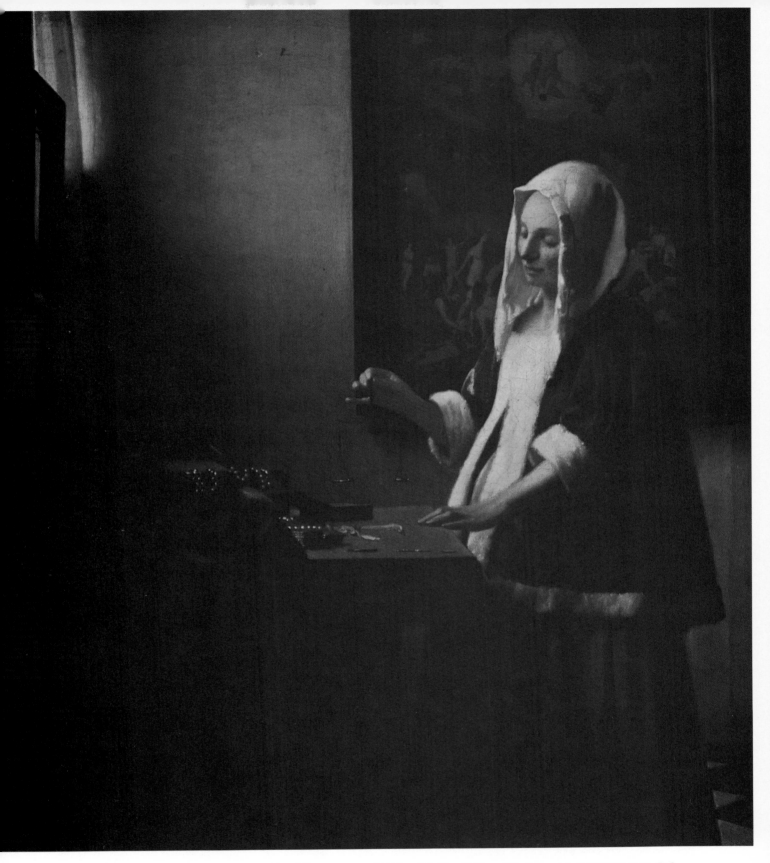

Jan Vermeer. *Woman Holding a Balance*. c. 1664. Oil on canvas, 16¾" x 15". The National Gallery of Art, Washington, D.C., Widener Collection. The artist has created a painting with a restful and quiet mood using contrasting *values*. Asymmetrical *balance* has been achieved with an almost equal *proportion* of darks and lights. *Emphasis* has been placed on the woman and the light source.

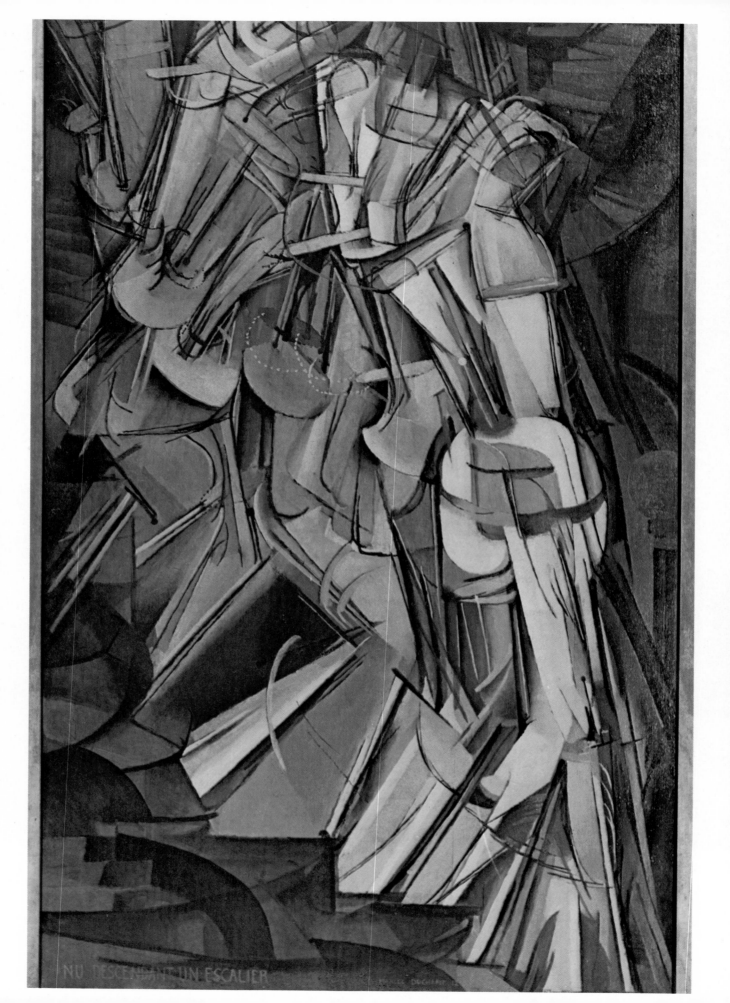

NU DESCENDANT UN ESCALIER

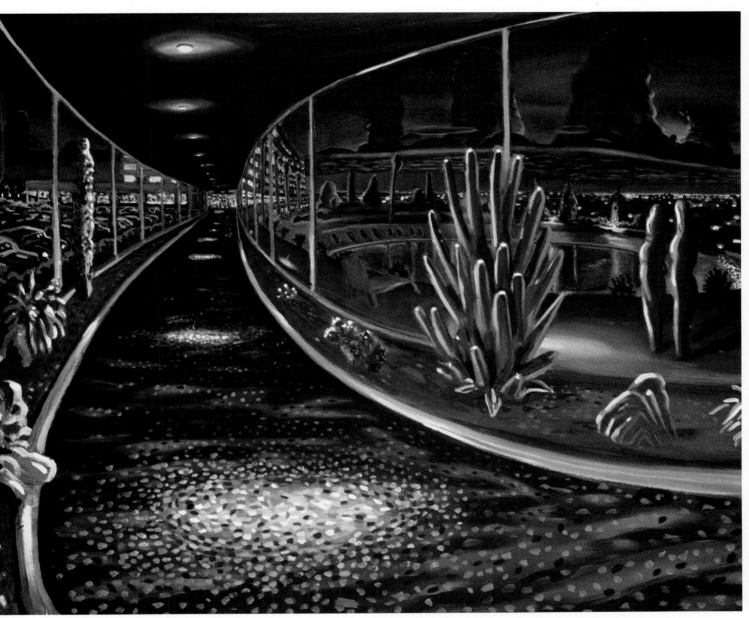

Robert Yarber. *Corridor.* 1984. Oil and acrylic on canvas, 80" x 72". Collection of the artist. Here the artist has achieved a sense of *movement* deep into the picture *space* through a contrast of *value* and *color* with neon-like *lines* and *textures*. left. Marcel Duchamp. *Nude Descending a Staircase, No. 2.* 1912. Oil on canvas, 58" x 35½". Philadelphia Museum of Art: The Louise and Walter Arensberg Collection. Marcel Duchamp, one of the pioneers or twentieth-century art, created a work of extraordinary *unity* by reducing the human figure to basic geometric *shapes*. Through *repetition* of these *forms* and *lines with a remarkable use of variation,* Duchamp created a sense of movement and rhythm.

Bill Francis. *Cycle of Life.* 1976. Cotton, rayon, and mixed media wall hanging. 4' x 10'. Republic Bank South, Austin, Texas. This horizontal wall hanging is made by combining fibers with other materials, such as plastic forms and shaped pieces of copper. When viewing the hanging, our eyes tend to move from the left, where white is predominant, to black on the far right. Shape slowly changes in color between the black at one end and white at the other. The shapes represent cell structures found in the human body and were inspired by biological shapes. The repetition of curving lines and shapes achieves unity in the total design. right. Egyptian: Eighteenth Dynasty. *Head of Tutankhamun on a Lotus.* c. 1335 B.C. Carved wood overlaid with gesso and painted, 11¹³⁄₁₆h. Cairo Museum, Egypt.

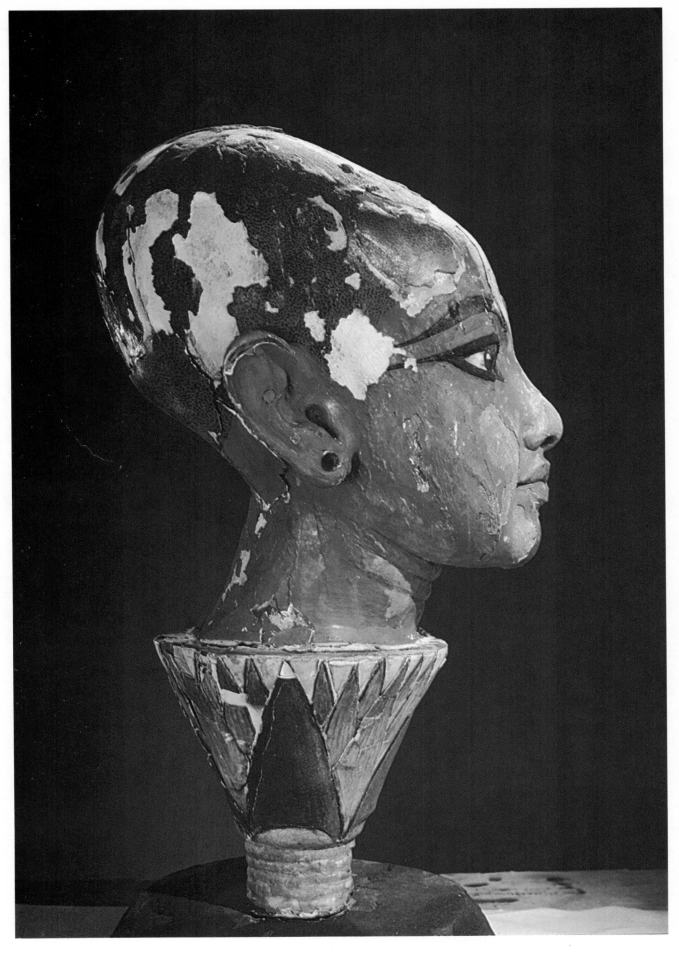

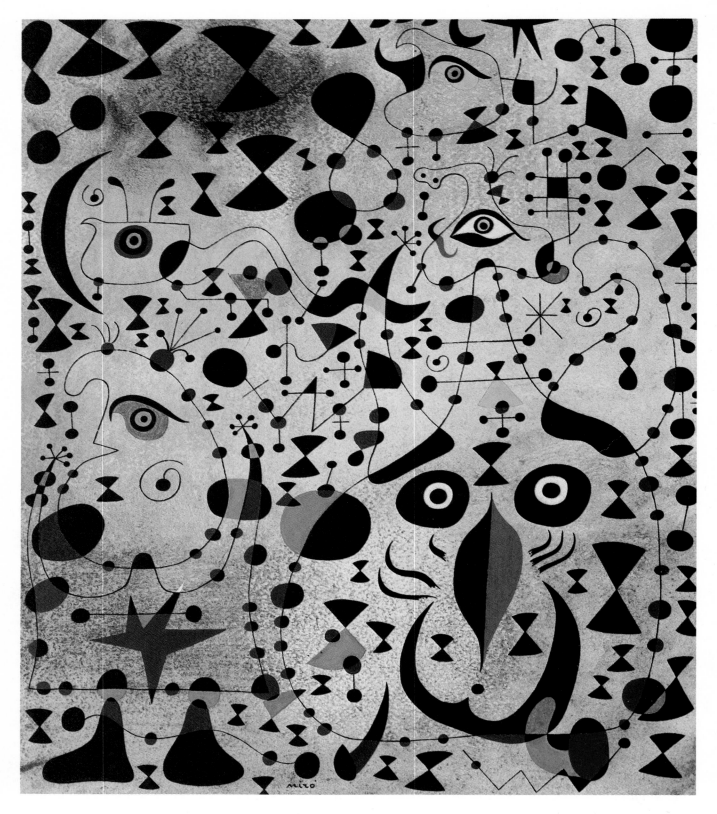

Joan Miro. *The Beautiful Bird Revealing the Unknown to a Pair of Lovers.* 1941. Gouache and oil wash on paper, 18" x 15". Collection of The Museum of Modern Art, New York. Acquired through the Lillie P. Bliss Bequest. What a happy and whimsical *rhythm* Miro has created by *repeating shapes* and *colors* and using *line* to *unify* them. right. Piet Mondrian. *Broadway Boogie Woogie.* 1942-43. Oil on canvas, 50" x 50". Collection, The Museum of Modern Art, New York. Given anonymously. This painting was Mondrian's last completed work. Keeping the space of the canvas flat, Mondrian has expressed pure *rhythm* through a wide *variety* of *repeated* as well as *contrasting* squares and rectangular *shapes* with *emphasis* on primary *colors*.

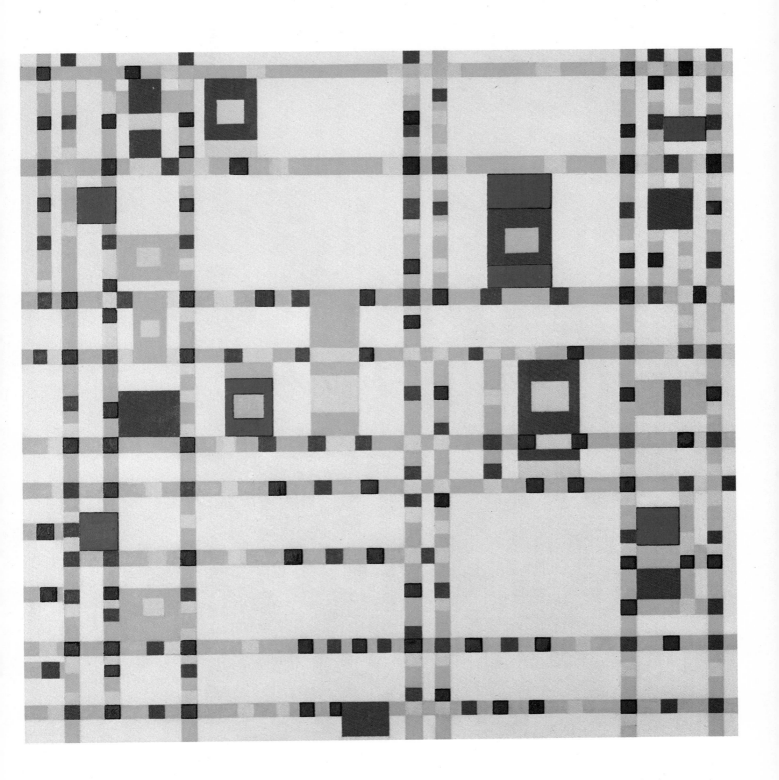

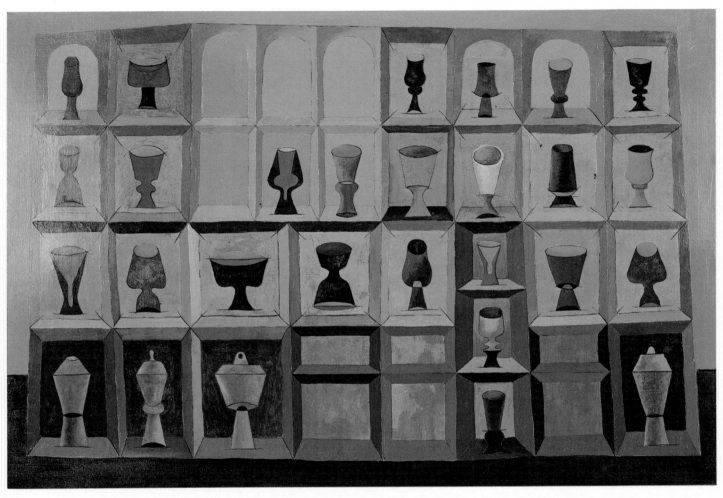

Bror Utter: *Pharmaceutical Cabinet II.* 1952. Oil on canvas, 28" x 40". The Fort Worth Art Museum. Gift of Pauline G. Evans. Bror Utter has used a variation of vessel *shapes* and rectangular *spaces*. Notice that some spaces are flat, while others contain depth. Three are empty and four are open to the blue beyond. Note also how the artist has changed the *color* and *value* in each *space*. This use of *contrast* and *variation* makes for a unified structured painting. left. Rebecca Brooks. *Planetary Visions: Iapetus.* 1984. Mixed media; collage, carbon printing, and colored pencil drawing, 26" x 22". Collection of the artist. Rebecca Brooks has created a very lyrical and poetic *space* using textures, rectangular *shapes* and *contrasting colors.* She has used symmetrical balance to give the work stability.

Sarah Canright. *Nebula.* 1984. Oil on canvas; 5 panels, 90" × 132". Courtesy of Pam Adler Gallery, New York. In *Nebula, space* and *structure* have been achieved through the use of *line*, both painted and real. The real or physical lines are created where the edges of the five canvases meet within the space of the painting. left. Sarah Canright. *Circle.* Oil on canvas, 84" × 60". Courtesy of Pam Adler Gallery, New York. In this large painting, a combination of three canvases, Sarah Canright has suggested forceful movement through *color, line,* and *light.*

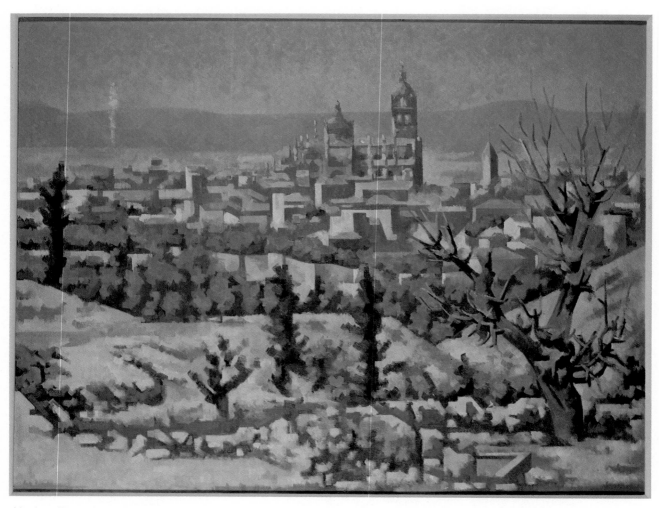

Loren Mozley. *Toward Segovia.* 1970. Oil on canvas, 25" x 32". Private collection. Loren Mozley painted this landscape from nature. He has created *unity* within this work through the many variations of rectangular shapes of contrasting values. There is a suggestion of movement starting with the horizontal bands of foreground to the trees and wall, buildings, mountains and sky. Note the interesting light line of smoke in the distance.

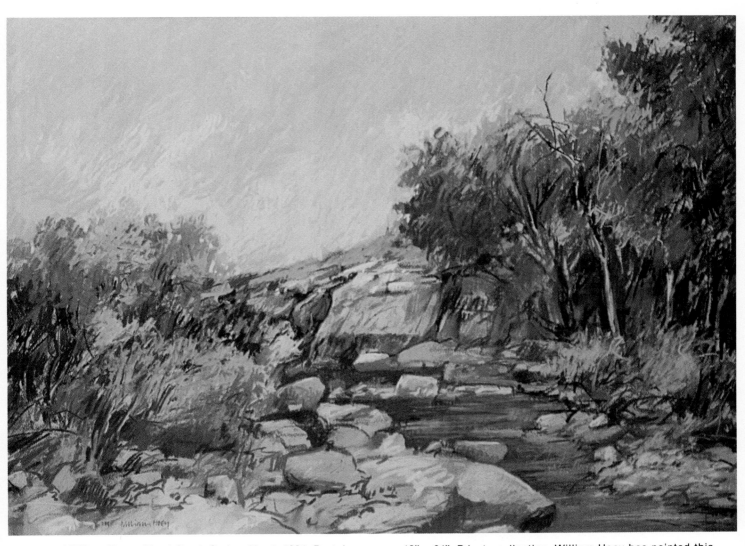

William Hoey. *Shoal Creek Series, No. 1.* 1984. Pastel on paper, 18" x 24". Private collection. William Hoey has painted this landscape from nature working outside. He has used a relationship of rock shapes with repeated variation. The vertical lines in tree trunks and the oval shapes of dark and light foliage give *contrast*.

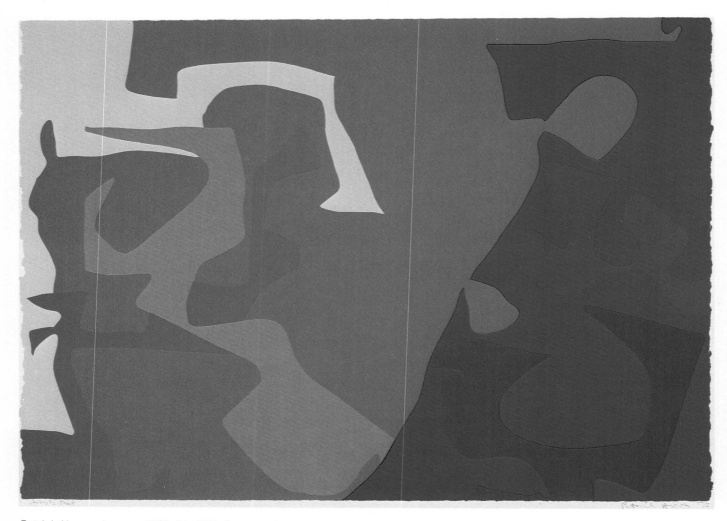

Patrick Heron. *January 1973: 11.* 1973. Screen print, artist's proof, 27¼" x 36". Collection of The Old Jail Art Center, Albany, Texas. Gift of Kelly Fearing. The renowned British artist, Patrick Heron, is considered a pioneer colorist, exploring the total experience of color in all of his work. He has this to say about his work and color: "For a very long time, now, I have realized that my overriding interest is *colour*. Colour is both the subject and the means; the form and content; the image and the meaning, in my painting today . . ."

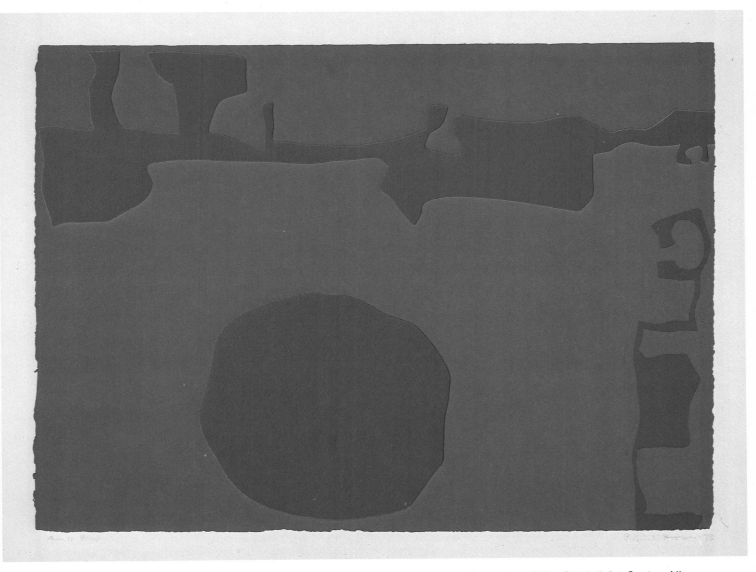

Patrick Heron. *January 1973: 3.* 1973. Screenprint, artist's proof, 27¼" x 36". Collection of The Old Jail Art Center, Albany, Texas. Gift of Kelly Fearing.

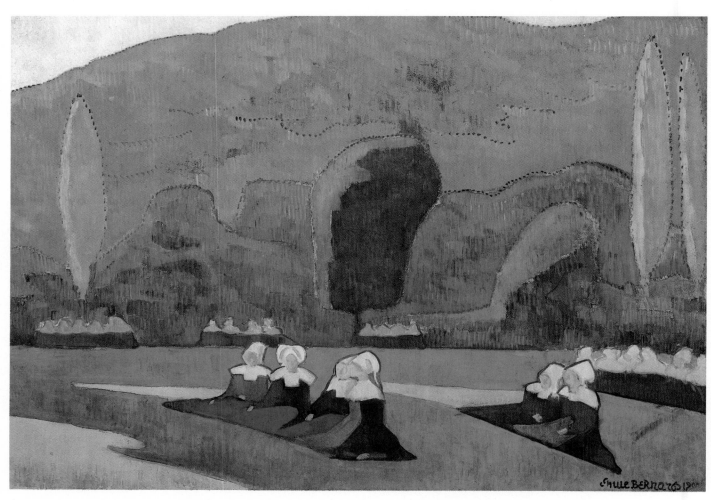

Emile Bernard. *Breton Women at Prayer.* 1892. Oil on cardboard, 32⅜ × 45¾" The Dallas Museum of Art, The Art Museum League Fund. Photo by David Wharton. *Contrast* of intense *color* and bold varied *shapes* are the dominant ingredients used to create this beautifully organized work.

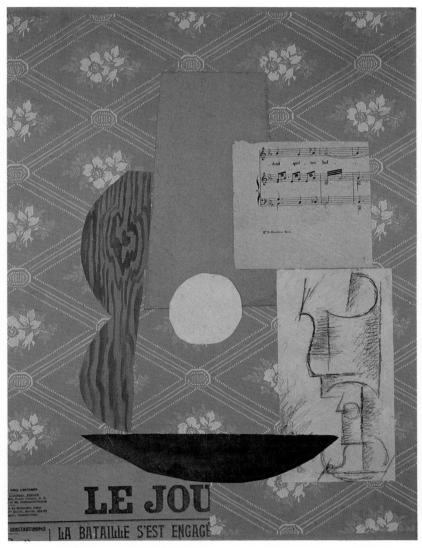

Pablo Picasso. *Guitar, Sheet Music, and Wine Glass.* Autumn. 1912. Charcoal, gouache and pasted paper, 24⅝" x 18½". The Marion Koogler McKay Art Museum, San Antonio. This collage was among the first made by Picasso in Paris in 1912 when he first invented collage. Cutting and pasting *shapes* from a variety of papers including newspaper, the wallpaper background, a fragment of sheet music, paper printed with a wood grain *texture* design, and a piece of paper with a charcoal drawing, Picasso has created a composition in his early Cubist style.

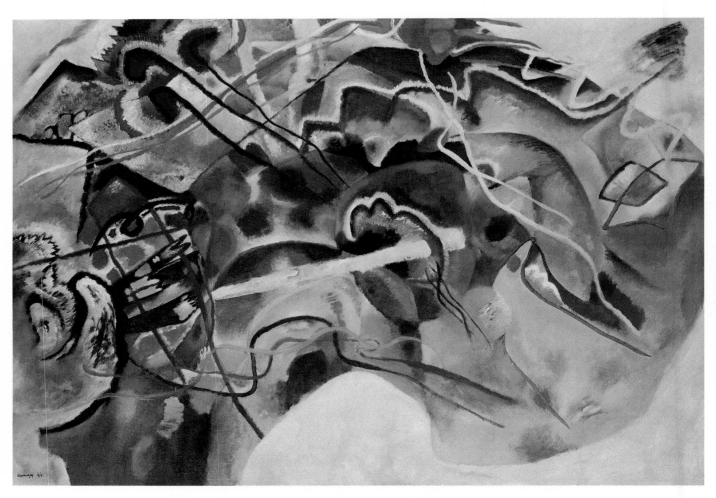

Vasily Kandinsky. *Painting with White Border.* 1913. Oil on canvas, 55¼" x 78". Collection, Solomon R. Guggenheim Museum, New York. Photo: Carmelo Guadagno.

Michael Mogavero. *Blueprint*. 1984. Oil on canvas, 86" x 72". Collection of the artist. Michael Mogavero paints large still life canvases. This painting is 6 feet wide and over 7 feet high. He uses large *shapes* to fill the *space*. Notice how the yellow lines have *movement* and at the same time represent grass. There is both inside and outside in the painting.

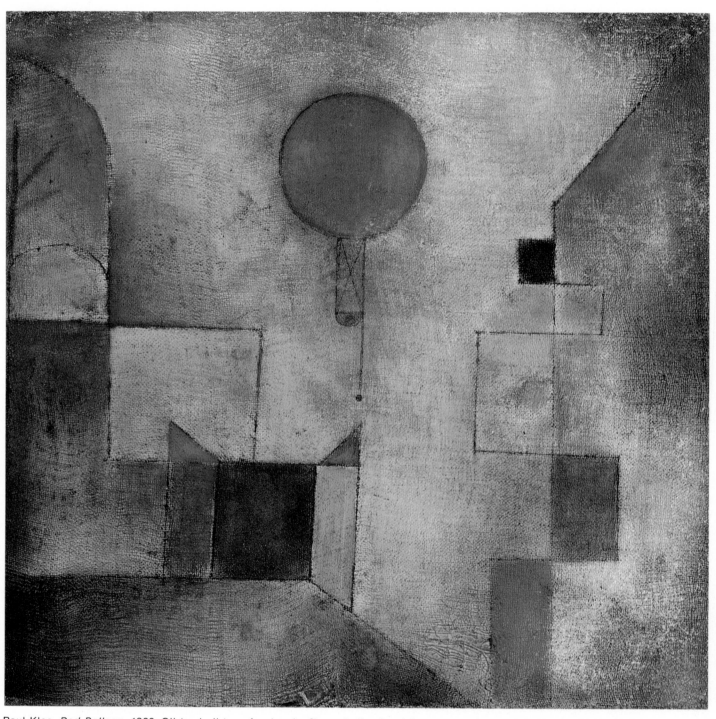

Paul Klee. *Red Balloon*. 1922. Oil (and oil transfer drawing?) on chalk-primed linen gauze mounted on board, 12½" x 12¼". Collection, Solomon R. Guggenheim Museum, New York. Photo: David Heald.

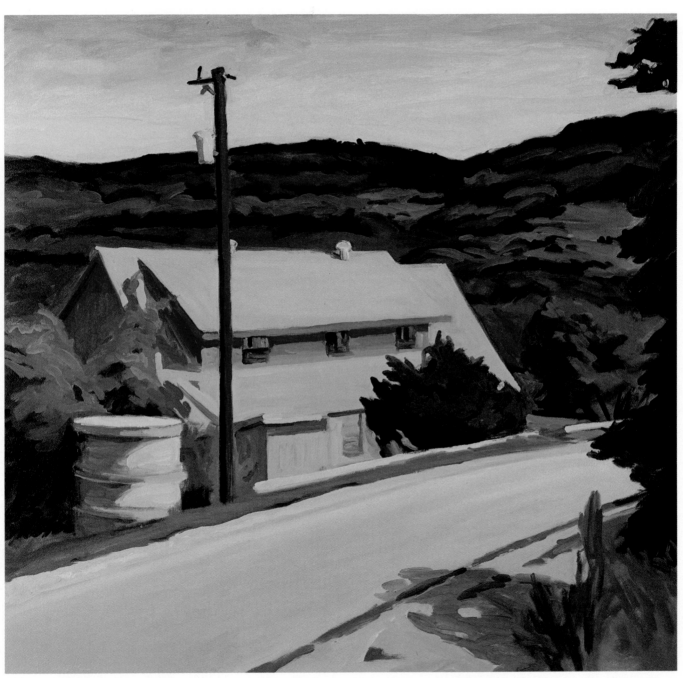

David Peacock. *House at Dusk*. 1984. Oil on canvas, 32" x 32". Courtesy of the Patrick Gallery, Austin, Texas. David Peacock looks directly at nature to find the *shapes* he has painted which make up this *balanced* composition.

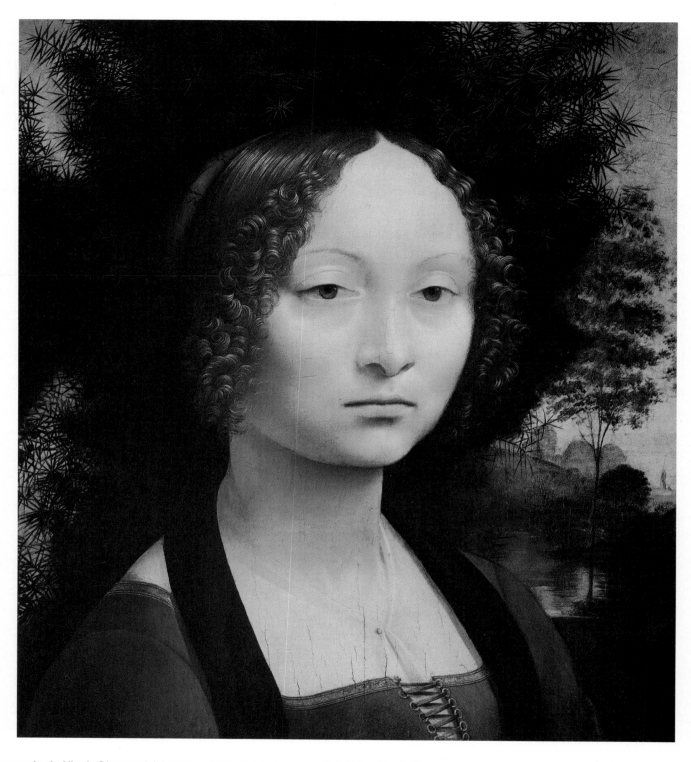

Leonardo da Vinci. *Ginevra de' Benci.* c. 1474. Painted on wood, 15⅛" x 14½". The National Gallery of Art, Washington, D.C. Ailsa Mellon Bruce Fund.

CHAPTER II
PORTRAITS AND THE HUMAN FIGURE

Since the days of the caveman, artists have been inspired to paint and sculpt the human form. The Egyptians made sculptures and used the figure in murals on the walls of tombs and large buildings. The Greeks were interested in the "ideal" human form. They made the human figure the most popular subject in their art. During the Italian Renaissance in the fifteenth century, there was a rebirth of interest in Greek and Roman art. Artists, such as Leonardo da Vinci and Michelangelo, became masters of human anatomy and proportions. Modern artists, like those of the past, study the people around them. They try to show personal characteristics, emotions, and gestures.

THE HUMAN FIGURE IN TWO DIMENSIONS

The more closely we observe the people we meet, the more we see. There are countless variations and interesting shapes of the human head. Also, the face shows something of the character and nature of every individual. The serious artist tries to capture the special quality of a person. No face is uninteresting or ugly to the artist. You too will grow in understanding through seeing and working in art. You will begin to appreciate the look of every person you meet.

Look at the portraits that follow. Notice how differently each artist has portrayed the subject.

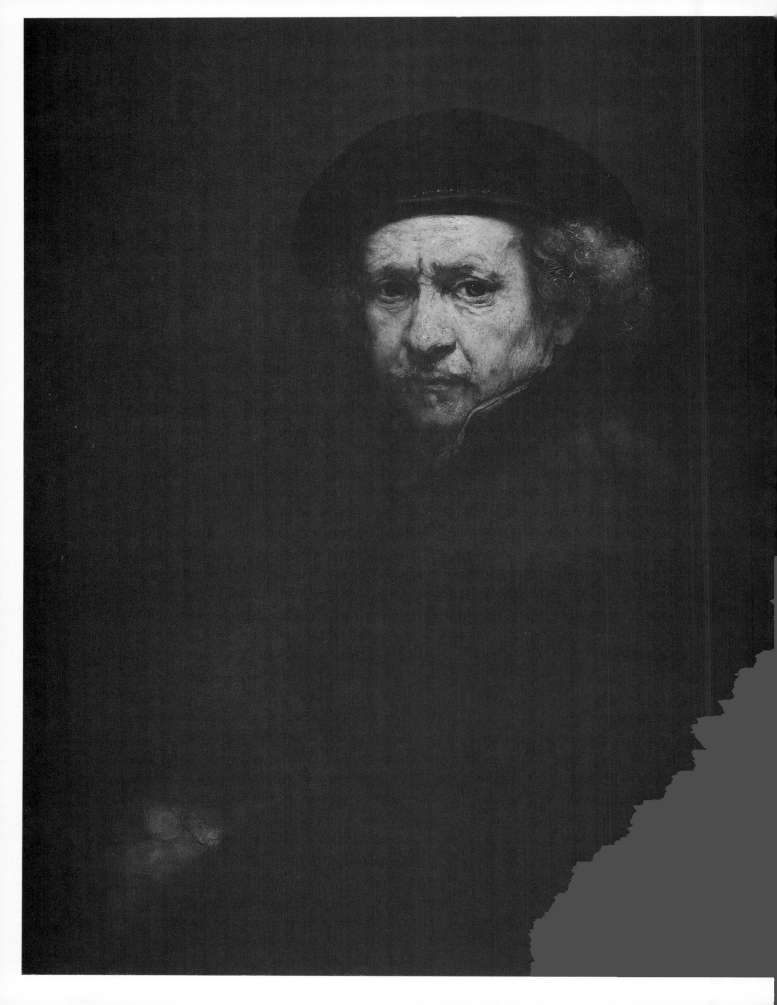

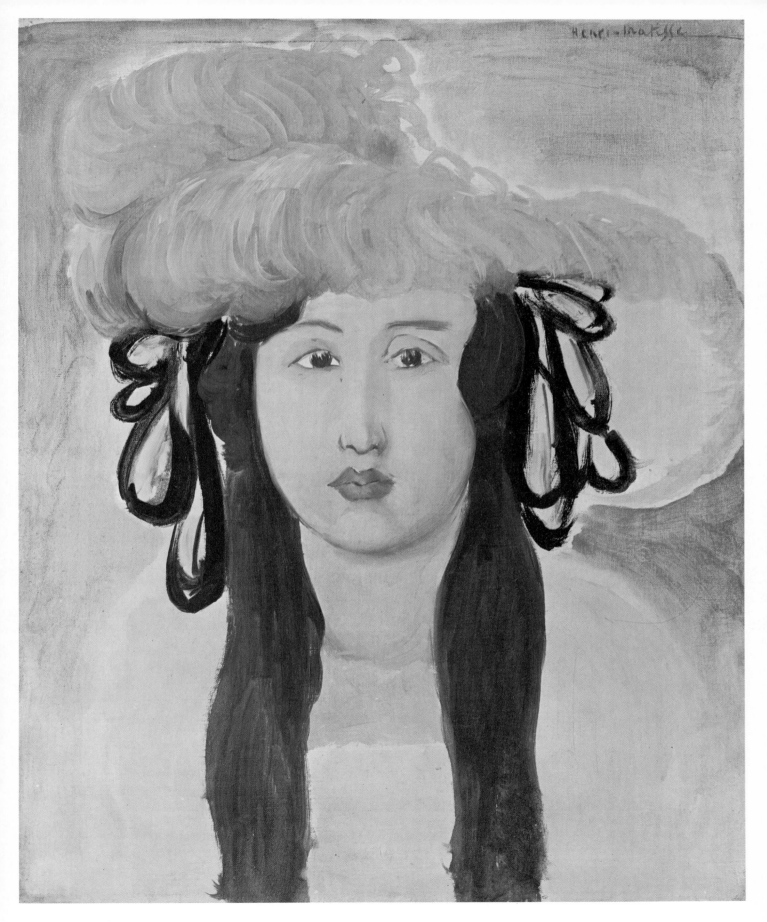

Henri Matisse. *The Plumed Hat*. 1919. Oil on canvas, 18¾" x 15". The National Gallery of Art, Washington, D.C., Chester Dale Collection. left. Rembrandt van Rijn. *Self-Portrait*. 1659. Oil on canvas, 33¼" x 26". The National Gallery of Art, Washington, D.C. Andrew Mellon Collection.

35

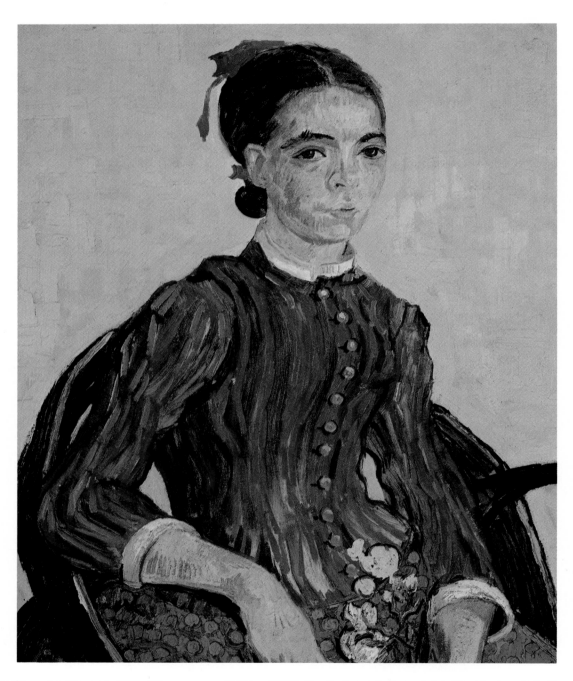

Vincent van Gogh. *La Mousmé.* 1888. Oil on canvas, 28⅞" x 23¾". The National Gallery of Art, Washington, D.C. Chester Dale Collection.

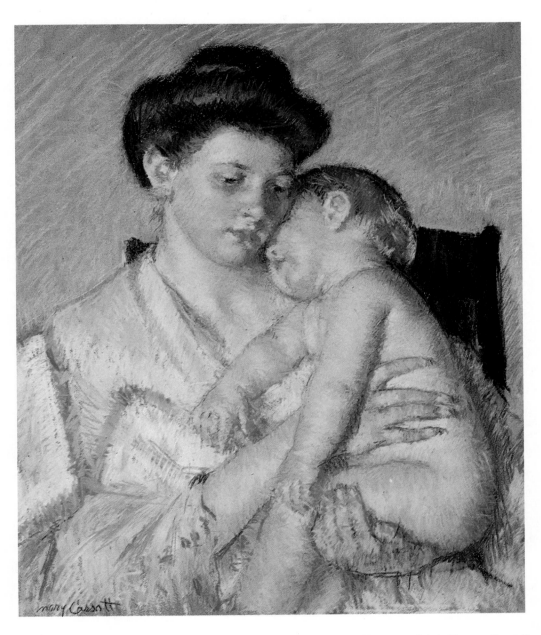

Mary Cassatt. *Sleepy Baby*. c. 1910. Pastel, 25½" x 20½". Dallas Museum of Art, Munger Fund Purchase.

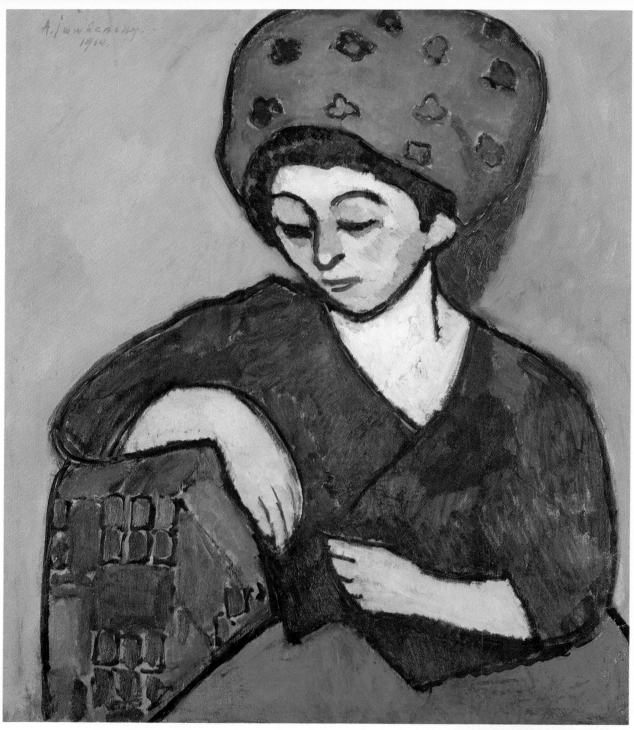

above. Alexej Jawlensky. *Helene with Colored Turban.* 1910. Oil on board, 37⅛" x 31⅞". Collection, Solomon R. Guggenheim Museum, New York. Photo: David Heald. right. Mort Baranoff. *Portrait.* 1963. Color intaglio print, 11¼" x 8¼". Collection of Timy Baranoff.

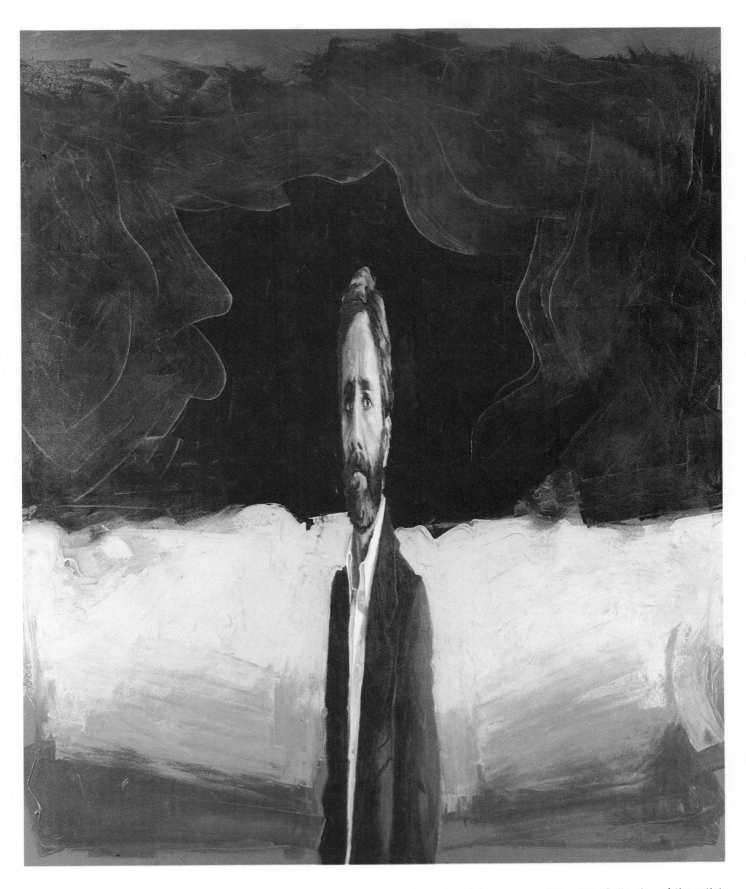

Bill Wiman. *Heat From a Black Sun*. 1984. Oil on canvas, 78" x 66". Collection of the artist.

When drawing and painting a portrait, the basic shape of the head must be carefully studied. It is sometimes helpful to see the head divided into very simple shapes and parts. Remember to kick the left-brain habit of naming things when you are drawing. If you focus on the shapes and relationships between features, you *can* draw them. Look at the head shown on this page. See how correct proportions can be found using a simple system of division. Individual faces will vary from this example.

Notice that the head is oval in shape. The eyes are halfway between the chin and top of the head. A portion of the forehead is hidden by hair. There is one eye's width between the eyes. Not all the iris (colored portions) shows, as it is covered by the eyelid. The bottom of the nose is halfway between the eyes and chin. The mouth is halfway between the nose and chin. How are the ears related to the eyebrows and nose? The neck is almost as wide as the jaws.

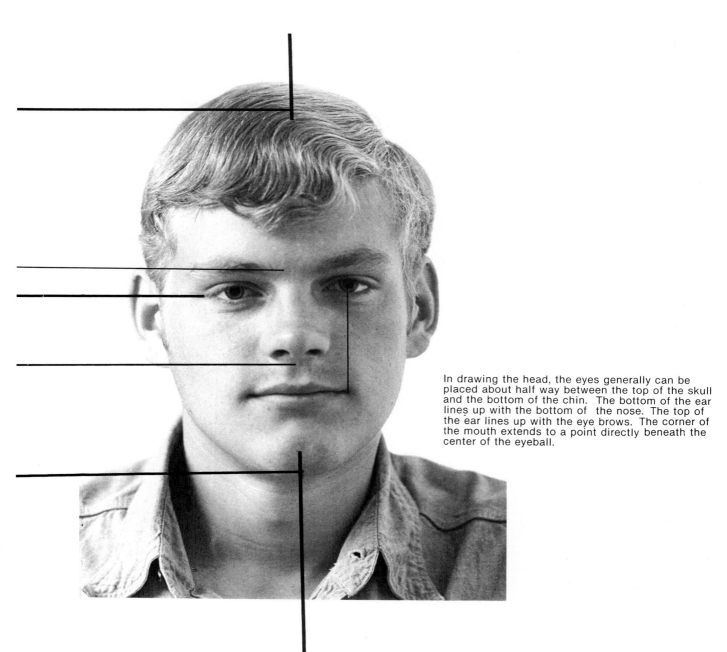

In drawing the head, the eyes generally can be placed about half way between the top of the skull and the bottom of the chin. The bottom of the ear lines up with the bottom of the nose. The top of the ear lines up with the eye brows. The corner of the mouth extends to a point directly beneath the center of the eyeball.

40

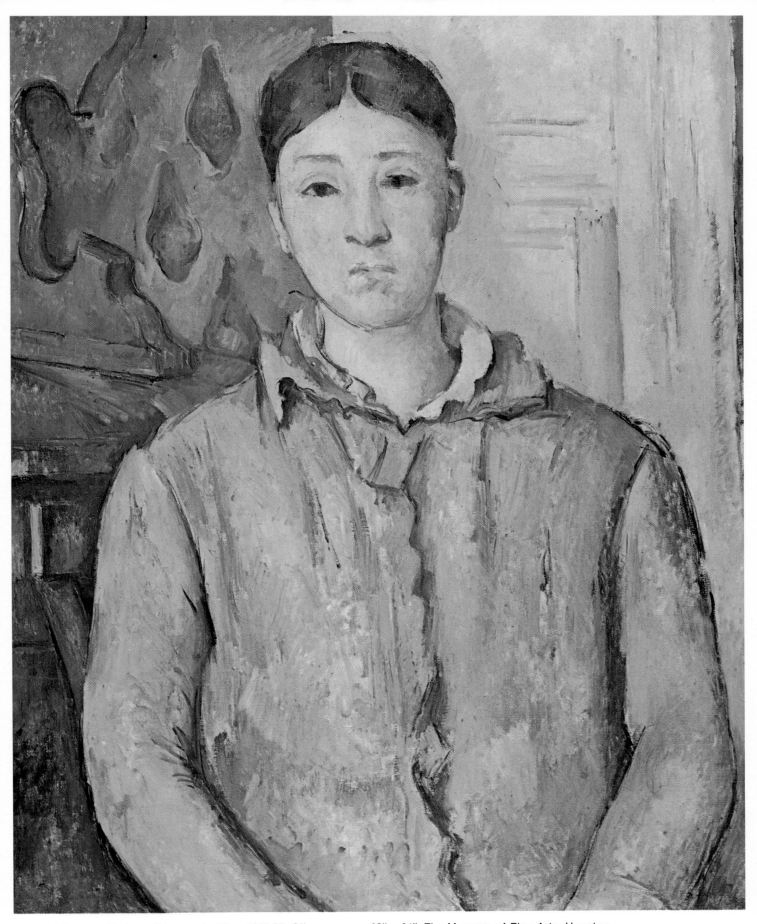

Paul Cézanne. *Madame Cézanne in Blue.* 1885-87. Oil on canvas, 29" x 24". The Museum of Fine Arts, Houston. Robert Lee Blaffer Memorial Collection.

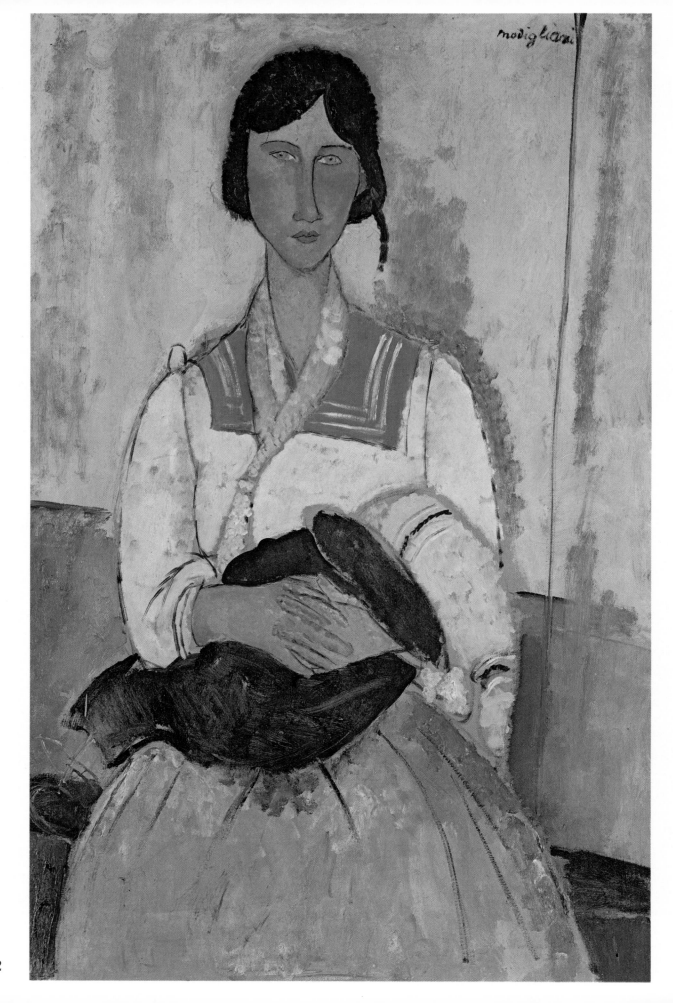

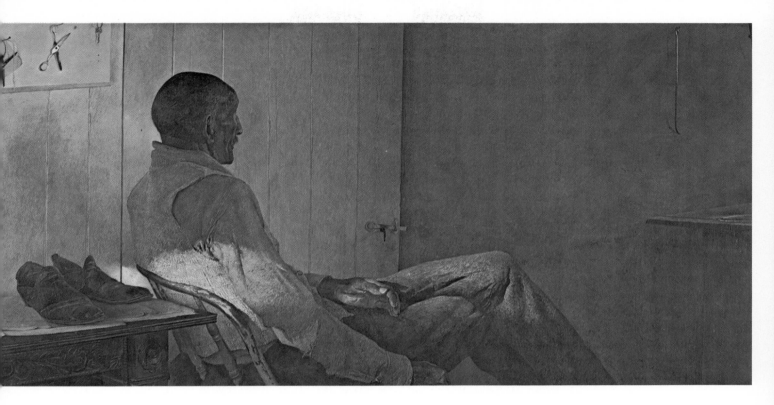

Andrew Wyeth. *That Gentleman.* 1960. Tempera on board, 23½" x 47¾". Dallas Museum of Art, Dallas Art Association Purchase. left. Amedeo Modigliani. *Gypsy Woman with Baby.* 1919. Oil on canvas, 45⅝" x 28¾". The National Gallery of Art, Washington, D.C., Chester Dale Collection.

THE HUMAN FIGURE

To draw and paint people in ways that are satisfying for you, study the human figure in action and at rest. How the body looks must be remembered. It is best to begin by having a model pose for short periods of time. Make quick action sketches during each pose. Take turns posing for one another. You may pose for yourself before a mirror.

Before beginning to draw, look carefully for the action or *gesture* of the model. Can you remember how it feels to turn, lean, climb, run, reach, or wave your arms in the air? Observe:

- the slant of the body
- the way the body bends at the waist
- the way the knees, shoulders, elbows move and bend
- which leg carries the weight of the body
- whether the head is straight forward, seen in profile, or turned slightly.

Caution: India ink and permanent markers can stain clothes.

Use pencil, ink and brush, felt-tip pens, charcoal or chalk and large paper. Stand as you work to give yourself more freedom. Draw quickly. Making quick gesture drawings of people in different positions leaves no time for erasing. You will need to make repeated lines in your drawings. You will be *searching with lines* to feel and show the movement of the figures. Draw large. Do not worry about details of the head or clothing. Show the *gesture* of the figure first.

For longer poses, try drawing with colored chalk. Again, look at the model carefully. Notice the relation of each part of the body to the whole figure. In this way your drawing will have the proportions and a feeling of completeness. Chalk allows you to add tones to your drawing. Use darks for the recessed and rounded parts of the figure. This gives an impression of sculptural or three-dimensional form.

Practice drawing the figure in action as often as possible. Make sketches whenever you have a chance to watch people—at a mall, a sports event, a park. You will draw faster and learn to look more carefully, drawing in ball-point pen or felt-tip marker. There is no way to erase! Do not be afraid to *scribble*! Remember it takes *many searching lines* to get the proportion and position of the human figure. Do not become discouraged if your first sketches are not as "good" as you had hoped. Try again! Artists spend years sketching and studying the figure. The more you practice, the happier you will be with your drawings.

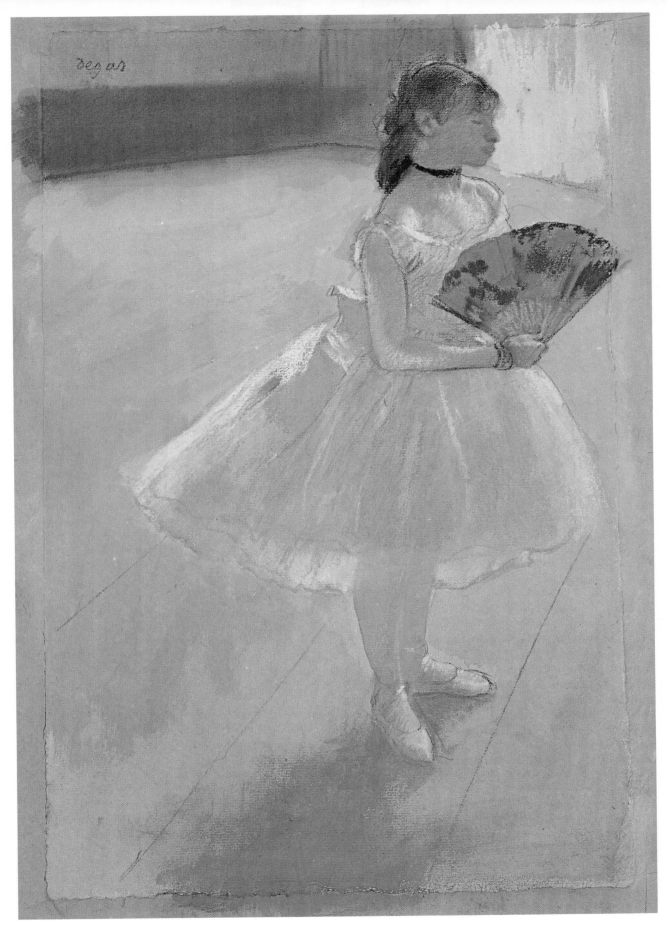

Edgar Degas. *Dancer with Fan*. 1879. Pastel on paper, 17⅜" x 11⅜". Private collection.

Robert Levers. *Chiliasts' Convention: Opening Ceremonies.* 1978. Watercolor and ink drawing on board. 12" x 20¼". Collection of the artist.

Stanton Macdonald-Wright. *Synchromy in Purple Minor.* 1918. Oil on canvas, 24" x 20". The Archer M. Huntington Gallery, The University of Texas at Austin, Michener Collection Acquisition Fund, 1970.

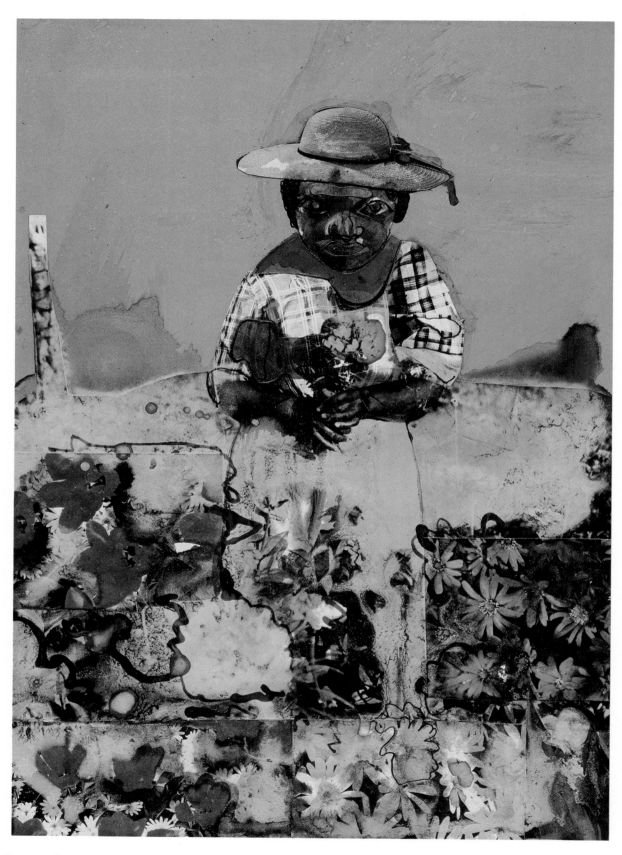

Romare Bearden. *Return of Maudelle Sleet.* 1982. Oil and collage on board. 12" x 8½". Courtesy of Malcolm Brown Gallery, Cleveland, Ohio.

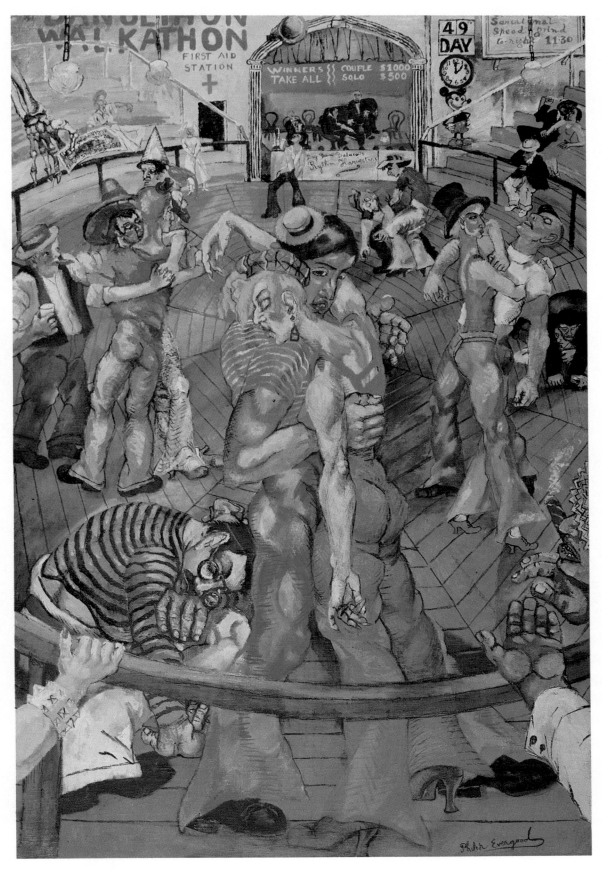

Phillip Evergood. *Dance Marathon.* 1934. Oil on canvas, 60" x 40". James and Mari Michener Collection, Archer M. Huntington Art Gallery, The University of Texas at Austin.

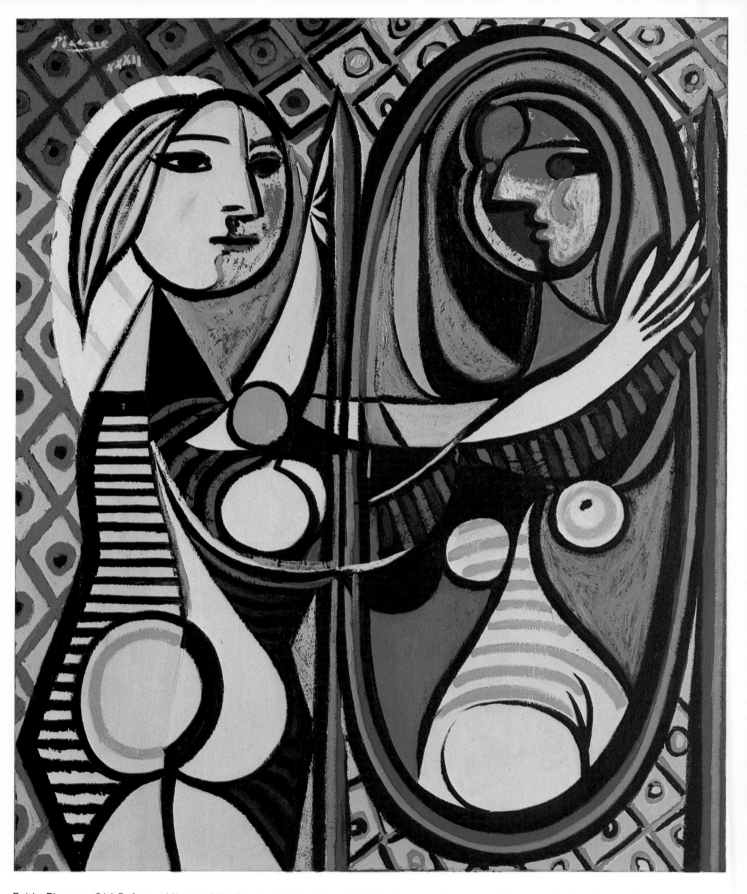

Pablo Picasso. *Girl Before a Mirror.* 1932. Oil on canvas. 64" x 51¼". Collection, Museum of Modern Art, New York, gift of Mrs. Simon Guggenheim.

FACES AND FIGURES: MAKE YOUR MARK!

1. Study your own face in a mirror. Observe your face from different angles. Notice how the position of features—eyes, nose, mouth—changes each time you move your head. Using a felt-tip pen or crayon, make several sketches of your face from different angles.

2. To check body proportions, many artists use the head as a way of measuring the height of a human figure. Study the illustration on page 52. Notice that the hips are in the middle of the figure and the knees are halfway between the hips and feet. When observing people around you, check to see how the size of the head relates to the height of figures. Look at someone standing and make a drawing. Draw an oval for the head. Check visually to see how many heads tall this figure would be—five? six? seven? Mark a line showing the location of the feet and hips in proportion to the head and rest of the body. Complete your drawing.

3. An artist carefully studies details of hands and feet in order to draw and paint them. Look at the photographs on page 53. Look closely at the variety of positions. Study the characteristics of each hand and foot. Using your own hand as a model, make several sketches of it in different positions. Notice how your hand is divided into two parts— palm and fingers. Your hand is about the same length as your face. Place the "heel" of your hand on your chin. Where do your fingers reach?

4. Cut out magazine photographs of close-ups of faces. Look at the different noses, ears, hairlines, eyes, and chins. Fill a page with details of features—three noses, ears, eyes and chins. Include one or two different hairstyles.

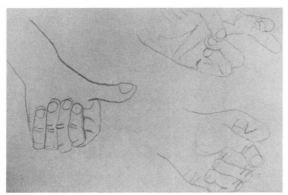

Student work.

Student work.

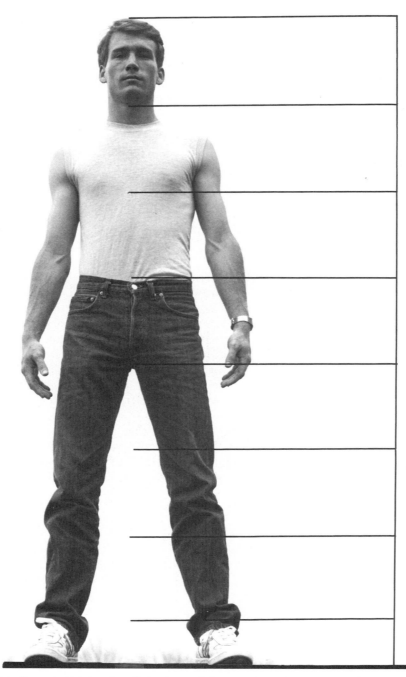

Notice in the photograph above that this figure is 7½ heads tall. Look carefully at the people around you, observing body proportions. A child may be only four or five heads tall due to his head being larger in proportion to his body than an adult's head is to a full-grown figure.

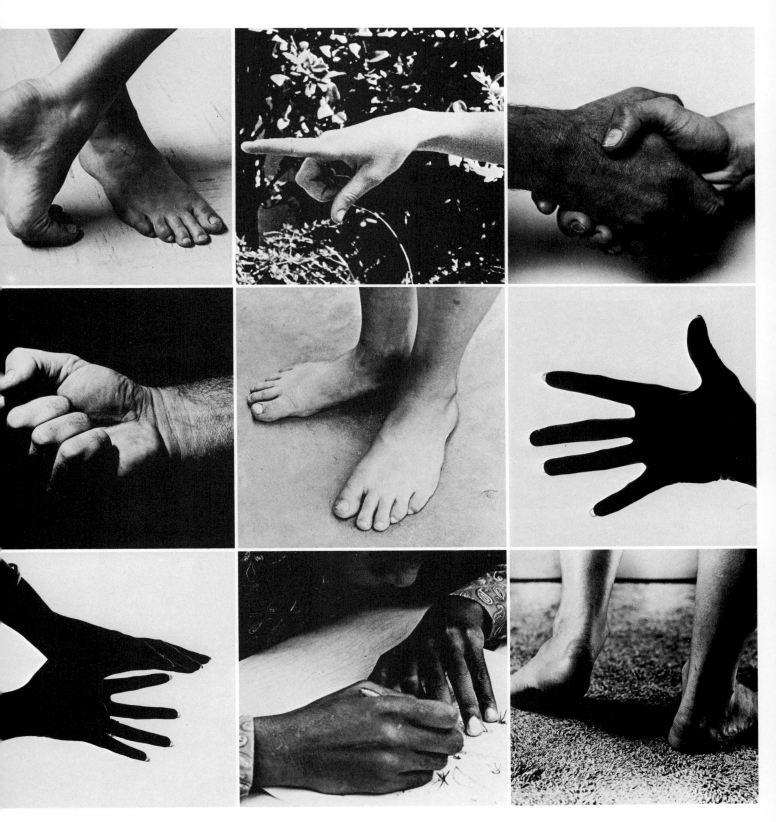

Human hands and feet can express a wide range of emotions, as well as present interesting forms. Photographs by Hans Beacham.

53

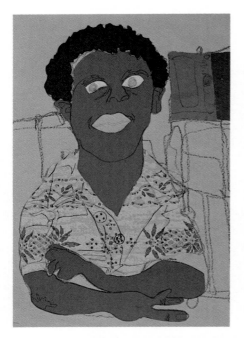
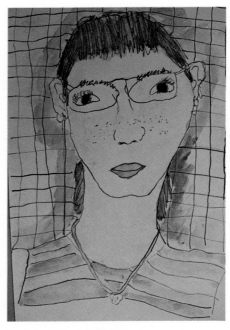
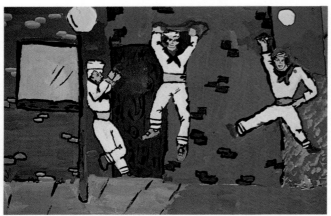
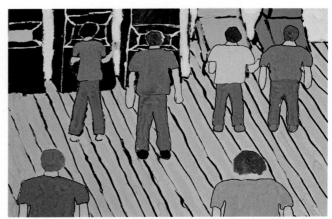
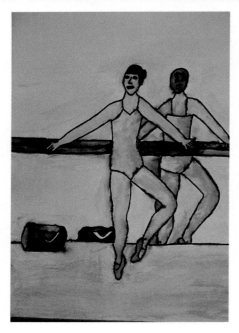
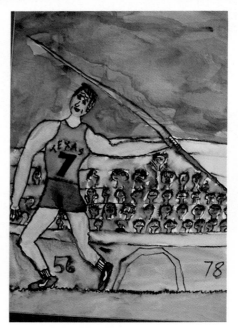

Figures. Student work in tempera, watercolor, collage, pen and ink.

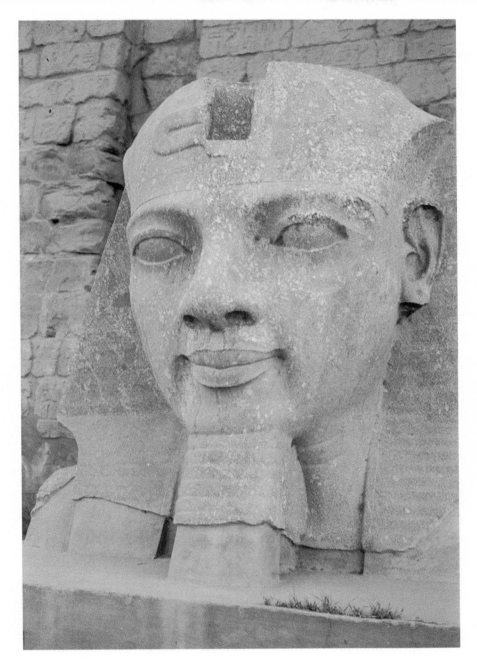

Head of Ramses II. Ancient Egyptian, Granite. Luxor.

THE HUMAN FIGURE IN THREE DIMENSIONS

An artist choosing to show the human form in sculpture, faces different challenges than when drawing, printing or painting. When working with wood, clay, plastic, metal or stone, the elements of *line, shape* and *texture* become real forms. They can be manipulated and moved about.

Bas-relief or low-relief sculptures are made to be seen from one view. Portions of the design are raised from the background as on a coin.

A sculptor creating a freestanding figure must imagine it from every angle—the top, bottom, and each side.

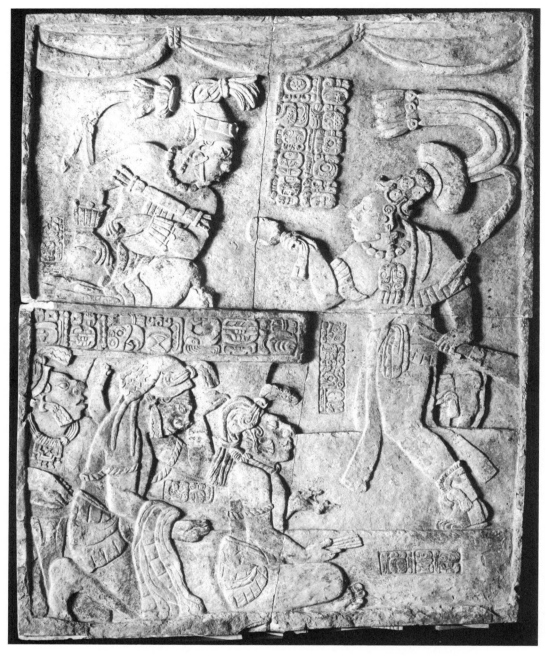

Pre-Columbian America, Maya. *Presentations of Captives to a Maya Ruler.* A.D. 782. From the Usmacinta Valley, 45¾" x 35". Kimbell Art Museum, Fort Worth, Texas.

Light is an important element in creating sculpture. Light gives life to the shapes, surfaces, and textures of the form.

Some artists choose to exaggerate portions of the human head or figure. However, they are still aware of the face and body proportions discussed earlier in this chapter. Keep this in mind as you study the works on the following pages. Also, note which works were created in bas-relief or low-relief and which ones are freestanding.

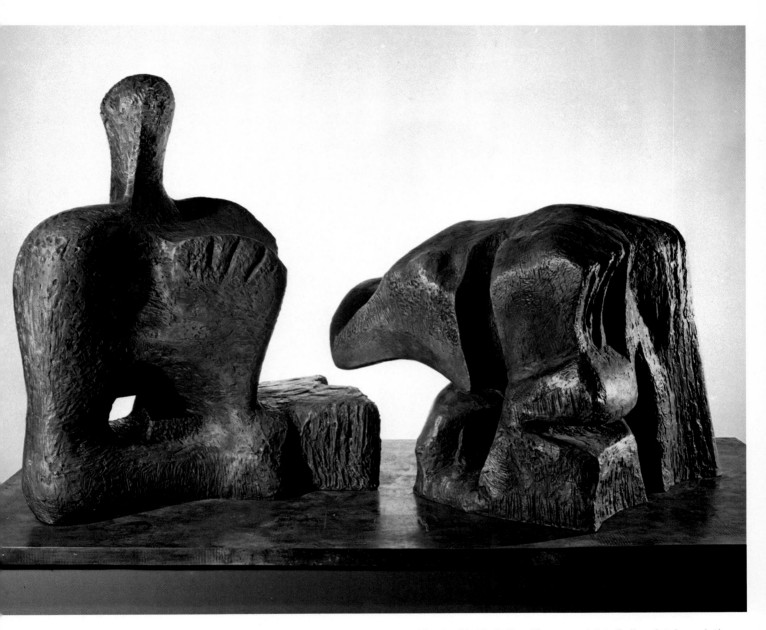

Henry Moore. *Two-Piece Reclining Figure, No. 3.* 1961. Bronze, 58¼" x 96⅜". Dallas Museum of Art, Dallas Art Association Purchase.

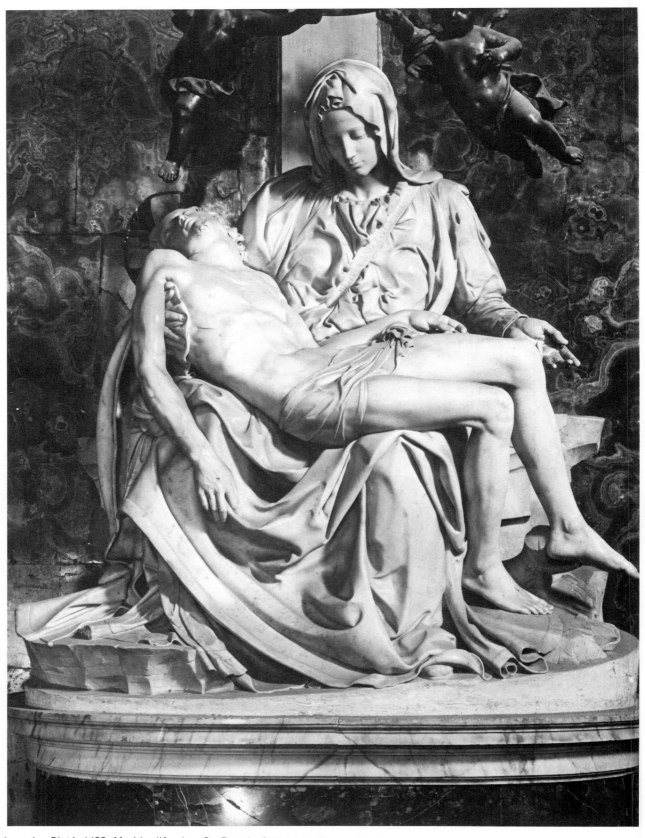

Michelangelo. *Pietá.* 1499. Marble, life-size. St. Peter's Cathedral, Rome. Credit: Alinari/Art Resource, N.Y.

right. Constantin Brancusi. *A Muse.* 1917. Polished bronze, 19⅝" x 11 11/16" x 9⅝". The Museum of Fine Arts, Houston. Museum purchase with funds provided by Mrs. Herman Brown and Mrs. William Stamps Farish.

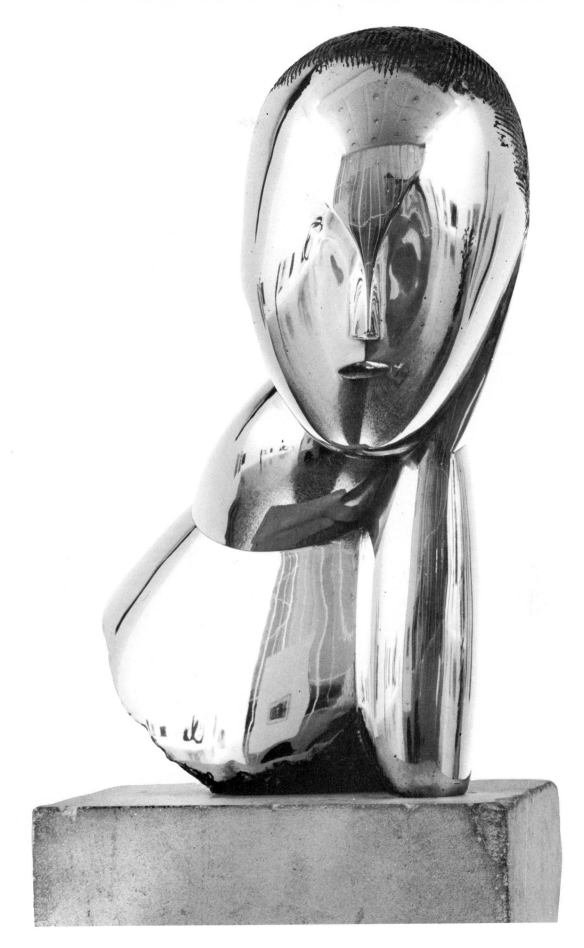

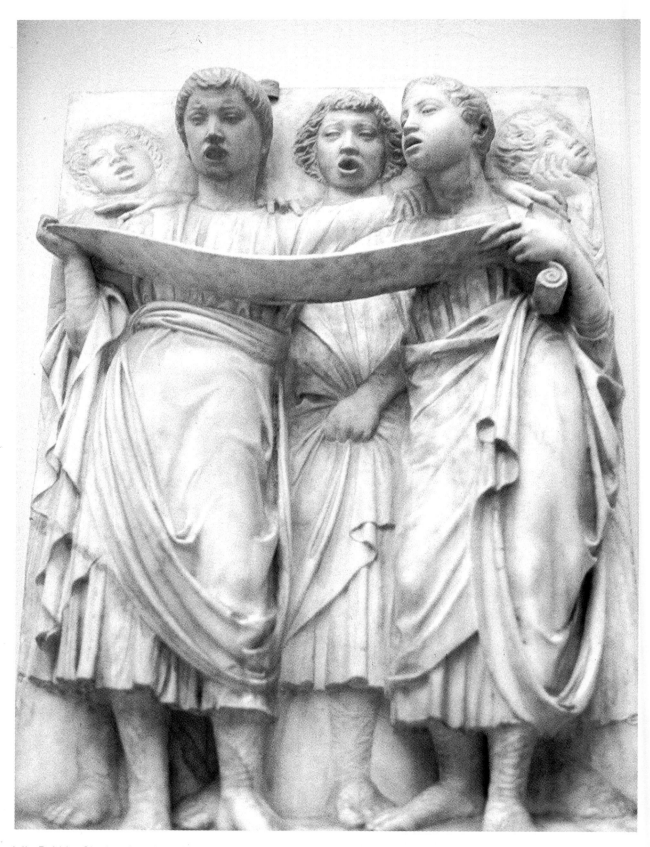

Luca della Robbia. *Singing Angels.* 1435. Marble. Cantoria, Cathedral Museum, Florence, Italy. right. Egyptian: Eighteenth Dynasty. *Head of Tutankhamun on a miniature coffin,* ca. 1325 B.C. Beaten gold inlaid with colored glass and carnelian, 8½" h. Collection of the Cairo Museum, Egypt.

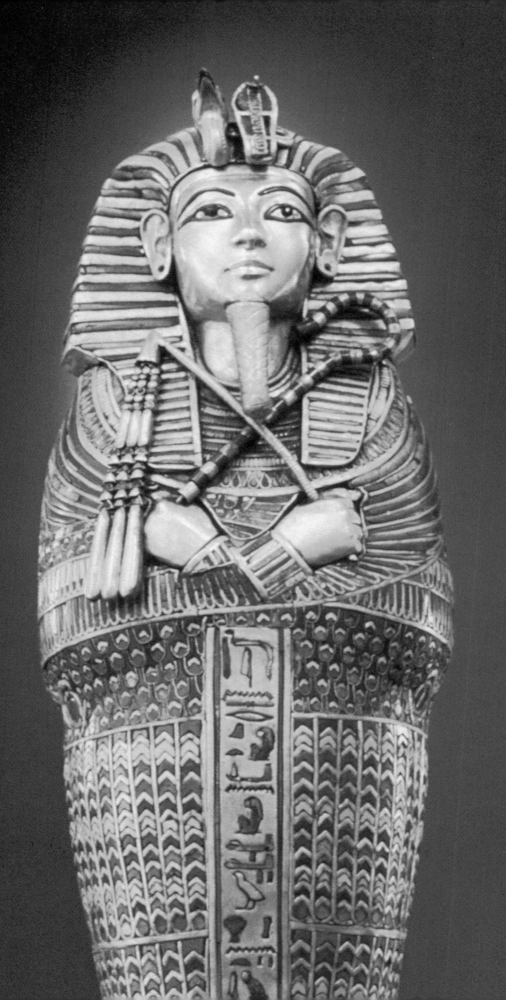

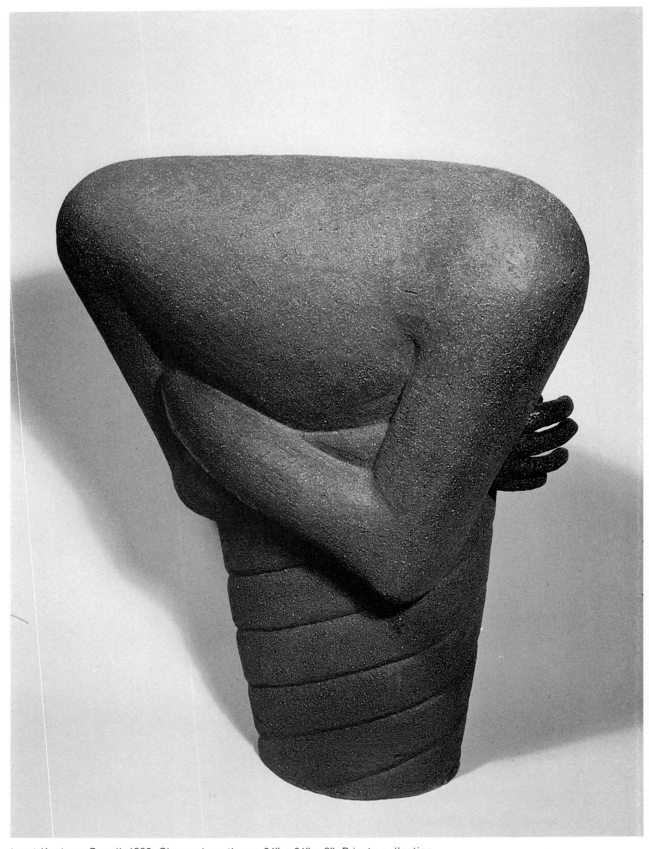

Janet Kastner. *Recoil*. 1982. Clay, polyurethane, 24" x 21" x 9". Private collection.

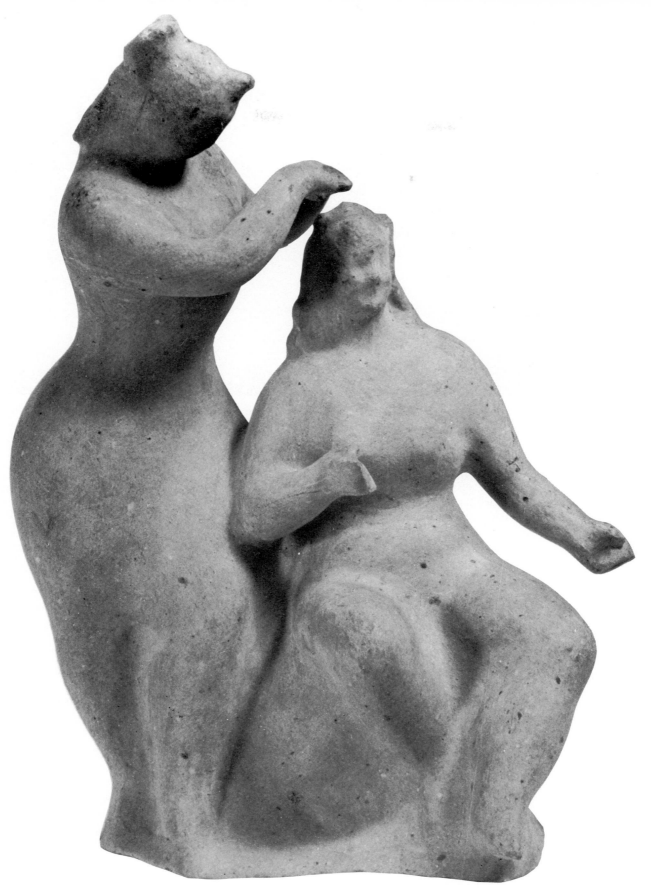

Elie Nadelman. *Two Women*. ca. 1938. Papier-mâché, 24" h., Private collection.

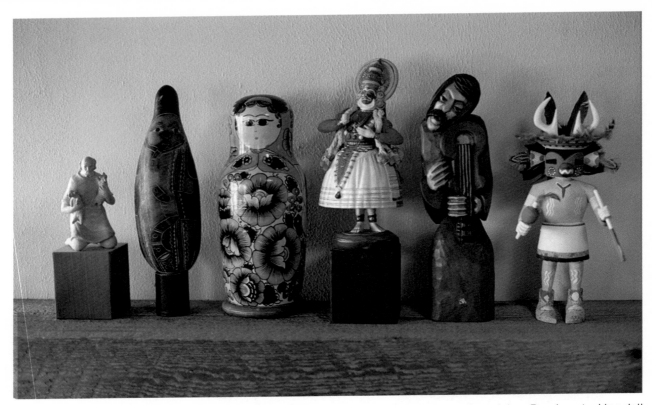

Contemporary Folk Art Figures. left to right: Guatemalan clay shepherd, Peruvian gourd musician, Russian stocking doll, Indian paper-mâché dancer, Polish musician: wood, Hopi Kachina doll: painted wood.

3-D FACES AND FIGURES: MAKE YOUR MARK!

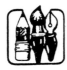

1. Use one white paper plate as the basic shape for a face. Cut parts of other plates or white construction paper to make nose, eyes, eyebrows, ears, mouth, beard, hair. Curl and fold parts in interesting ways to make shadows and textures. Look at the relief masks on page 65. These masks were made by students, after studying slides of marble masks, from glue or staple parts to the basic shape. Think of a way to hang the mask.

2. Picasso often drew and painted the human face. He sometimes showed two or more views in one work. On one sheet of construction paper, draw a life-size head and neck from a front view. On another sheet draw a head seen from the side (a profile). Cut them out. Draw features in the correct proportions on *both* sides of each face. Use felt-tip markers to darken lines or color the faces with crayons. Cut the front view in the center from the tip of the head to the bridge of the nose. Cut the profile *up* from the chin to the bridge of the nose. Insert the two parts at right angles as shown in the diagram on the opposite page. Attach thread to the top and hang as a mobile. A mobile is a construction set in motion by air currents.

3. Using what you have learned about body proportions, create a mobile of body parts. Sketch all the major body parts first—head, neck, trunk, forearms, upper arms, hands, thighs, etc. Choose cardboard, metal, wire or some other material for the mobile. Attach parts together with wire or string and hang.

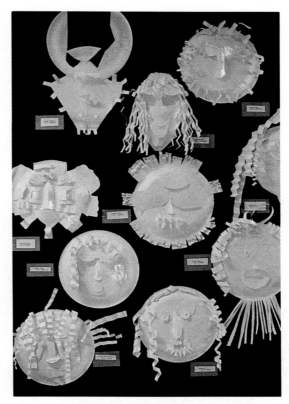

Relief masks from paper by students.

This diagram shows how to assemble the mobile project described in Make Your Mark! #2, page 64.

4. Search for soft wire (aluminum, telephone, brass, etc.) to make a complete figure in action. Remember that when drawing a figure, it is important to show the gesture or action. Decide upon a particular gesture and create it with wire. Experiment with the wire. Twist and wrap it around a pencil or tool handle to add dimension to the body parts. Make sure your figure is balanced. You may wish to attach it to a block of wood for a base.

5. Choose a piece of soft wood from a woodpile or buy a block of balsa wood from a hobby store. With a pocket knife, carve a three-dimensional portrait or figure from the wood block. *Caution:* Always handle knives carefully. Always cut *away* from the body, never toward it. Make a quick sketch of the form as it will appear from the side and front. You will see that a sculptor must think about *all* sides of a piece while carving.

above and right. Three dimensional mask and figures by students.

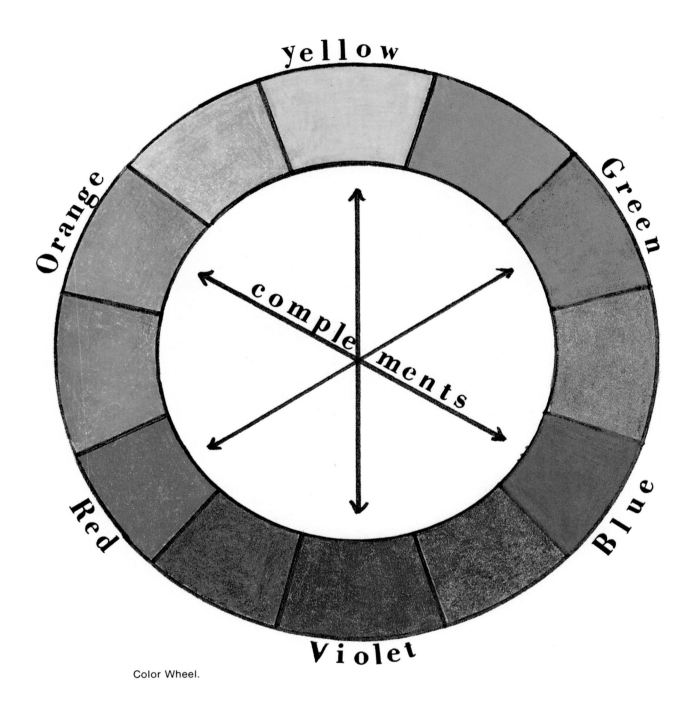

Color Wheel.

CHAPTER III
EXPLORING TECHNIQUES AND MATERIALS
COLOR SCHEMES

In Volume One of this book you learned several new things about color. We discussed how color has three characteristics. *Hue* is the name of the color. *Value* is amount of lightness or darkness. *Intensity* is the brightness or dullness of a color. You also discovered that the *primary* colors—red, blue, yellow—mixed together in pairs make the *secondary* colors—green, orange, violet. As human beings we enjoy color and respond to moods created by the use of various colors. Warm colors can make us feel happy and excited. Cool colors can have a calming, soothing effect on us.

Artists through the centuries have explored how color affects our moods. They discovered that one way to create a pleasing arrangement of colors is to group the colors into systems called *color schemes.*

The three color schemes most often used are *monochromatic, analogous,* and *complementary.* Few artists use these color systems exactly as described without some changes. However, an understanding of the three color schemes listed above will help you as a beginning artist. You will learn to select and combine colors in new ways.

Monochromatic

The word *monochromatic* gives you an important clue to the kind of color scheme involved. *Mono* means "one" and *chromatic* means "color". Therefore, a *monochromatic color scheme* uses only one color. The color is changed in *value and intensity* by adding black and white. In a monochromatic color scheme black and white are not considered colors in the same way that red, blue, or green would be. A monochromatic color scheme creates a strong mood in a painting as well as adding an important design principle, *unity.*

Analogous

Look at the color wheel on the opposite page. The colors red, red-violet, violet, blue-violet are next to each other or "neighbors" on the color wheel. These hues or colors create an *analogous color scheme.* Another analogous color scheme might be made of yellow, yellow-orange, orange, and red. You may choose any neighboring colors as long as the "neighborhood" stays within the bounds of two primary colors. Analogous color schemes offer more variation than a monochromatic scheme. They also create *unity* and mood.

Complementary

Look again at the color wheel. What color is opposite blue? Opposite red? Opposite yellow? The colors, orange, green, violet, are the *complements* of blue, red, and yellow. When you want to use a *complementary color scheme*, choose two colors opposite each other on the color wheel.

More interest and variation can be added by mixing black and white with complementary colors. A *tint* is made by mixing white with a color. A *shade* is made by mixing black with a color. When complementary colors are mixed together, the colors look brownish or muddy. When used side by side, complements strengthen each other. You might find a complementary color scheme helpful in creating a feeling of excitement in your painting.

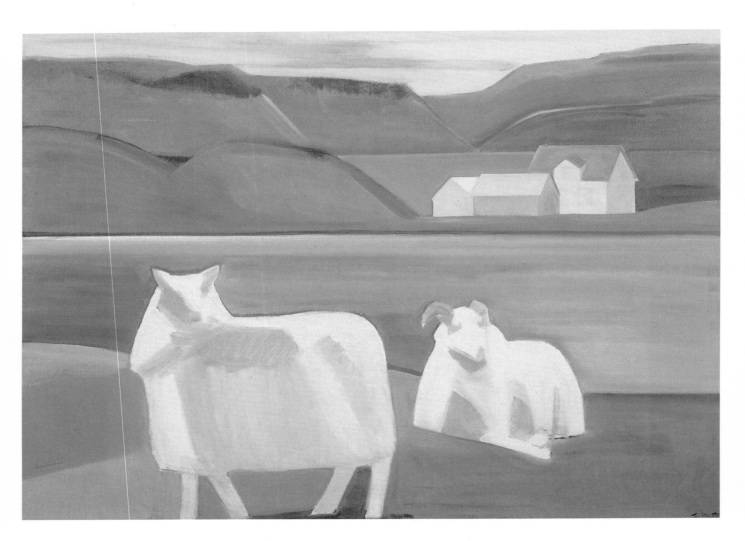

Louisa Matthiasdottir. *Two Sheep*. 1982-83. Oil on canvas, 52" x 72½". Archer M. Huntington Art Gallery, The University of Texas at Austin. The 1984 Friends of the Archer M. Huntington Art Museum Purchase. The artist makes use of complementary colors, tints, and shades.

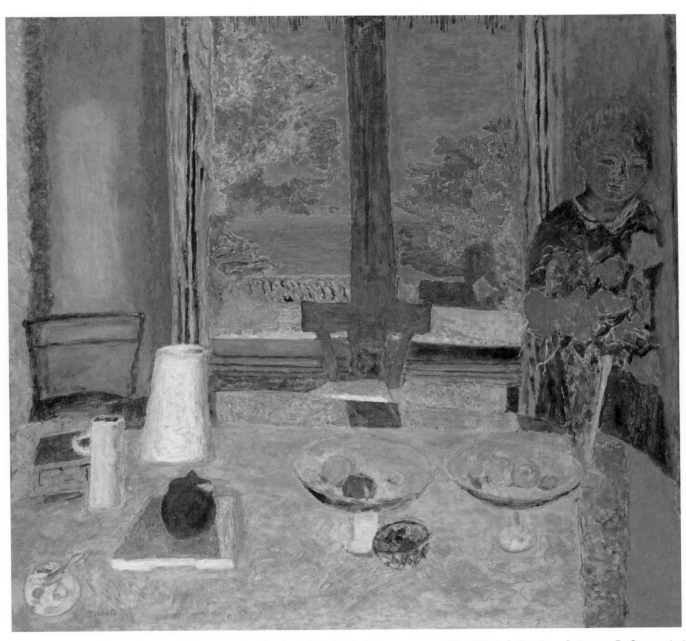

Pierre Bonnard. *Dining Room on the Garden.* 1934-1935. Oil on canvas, 50" x 53¼" Collection, Solomon R. Guggenheim Museum, New York. Photo: Carmelo Guadagno.

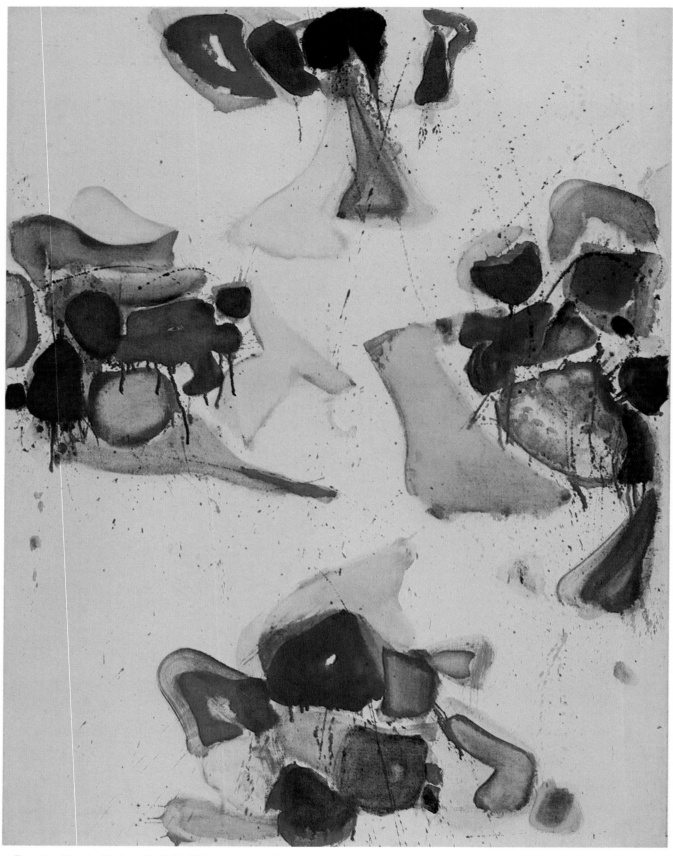

Sam Francis. *Blue in Motion, II*. 1960. Oil on canvas, 45½" x 35". James and Mari Michener Collection. Archer M. Huntington Art Gallery, The University of Texas at Austin. By the use of a monochromatic color scheme, artist Sam Francis creates a feeling of peace and serenity, while at the same time giving unity to his composition. right. Alvin Nickel. *Sun Totem III*. 1968. Batik on cotton, 68" x 45". Collection of Beryl Weiner, Los Angeles.

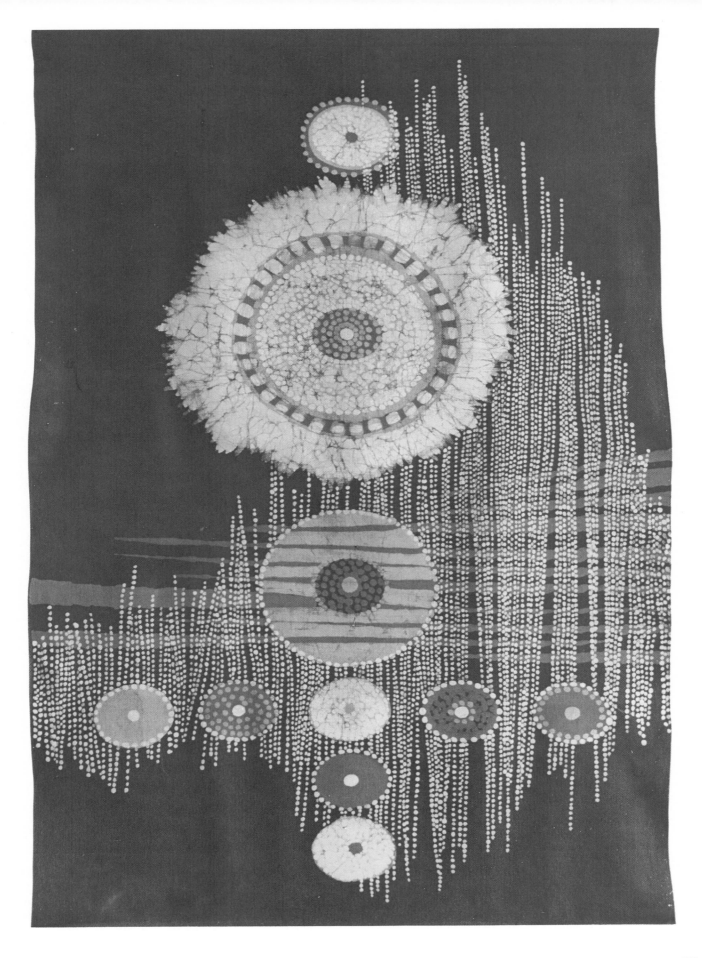

COLOR SCHEMES: MAKE YOUR MARK!

1. Practice mixing the *primary* colors to make the *secondary* colors. Along the top of a piece of white construction paper place a dab of each primary and secondary color. Mix each with white, then black. Notice how adding white and black changes the *intensity* and *value* of the color. On another sheet of paper make the following colors: yellow-green, blue-green, pink, gray, blue-violet, red-violet, red-orange. You may use either tempera or watercolor for your color mixing practice.

2. Think about a mood or feeling you have felt, such as happiness, sorrow, fear, peacefulness. Choose one color which you feel best expresses this mood or feeling. Using tempera paint or watercolors, paint a self-portrait in the one color you have chosen. For shadows and highlights mix black and white with your color.

3. How many types of weather can you name? Rain and snow are easy, but can you think of others? Select some kinds of weather—sunny and hot, rainy and cold, humid and warm. Paint an imaginary landscape using an *analogous color scheme*. Think about the mood and climate of places like the Arctic, the desert, or the jungle. Choose your "family" of analogous colors to create the mood and feeling you have picked for your landscape. Remember, your "neighborhood" of colors should not extend beyond two primary colors. Check the color wheel on page 68 for review.

4. For your *complementary color scheme* painting, choose a subject from the following:

 > Carnival Time
 > Circus
 > The Championship Game
 > 4th of July Parade
 > Flower Market

Limit your colors to two complementary colors plus black and white. Complementary colors can create tension and excitement when used side by side. Both tempera paint and watercolors on white construction paper work well.

Each of the student works on the opposite page uses a monochromatic color scheme to create two very different moods. Cool colors dominate the underwater scene, while warm colors add excitement to the cityscape. Color schemes can also be used to create unity in works other than paintings and drawings. For example, students used what they learned about monochromatic and analogous color schemes in designing these batiks and weavings.

PERSPECTIVE

In the seventh grade you learned that perspective can create the illusion of deep space on a piece of paper. You worked with *one-point* and *two-point perspectives*. Many drawings of buildings seen in newspapers and magazines use one of these types of perspective. However, there is much more to the set of rules known as *linear perspective*.

As you grow as an artist you will want to draw and paint more complicated subjects. You will want to draw and paint skyscrapers, cars, trains, spacecraft, furniture, and interior spaces. All these subjects, to look real, must be drawn in perspective.

Review one- and two-point perspective presented in the diagram below. As you review remember:

1. All lines in a perspective drawing, *except the vertical ones*, extend to a *vanishing point* on the *horizon line*. This line represents the eye-level of the observer.

2. A one-point perspective drawing will use *one* vanishing point. All lines (except vertical) meet at this point.

3. Two-point perspective drawings use *two* vanishing points on the horizon line. They show the *corner* view of a building.

All three-dimensional structures can be drawn in perspective. However, you must first reduce the shape to simple geometric forms, like cubes or boxes. Once you have drawn the boxes in perspective, you can "cut" away corners to reveal the object. The diagram below will give you an idea how this is done.

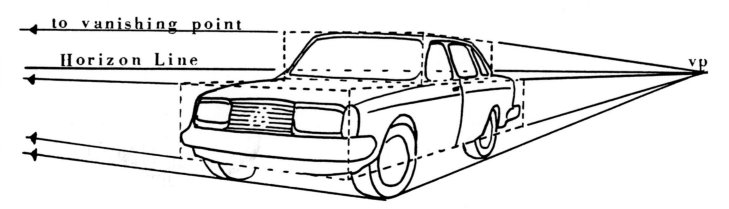

Two-point perspective.

Drawings of the inside of a building use the same rules of perspective but with some changes.

Look at the diagram below. Notice that to draw a room in one-point perspective, you use the same rules as when you draw the outside. Always draw the vanishing point and horizon (eye-level) line lightly. You will be erasing these lines. You need to show *walls* rather than open spaces! Notice how the objects in the room follow the rules of perspective.

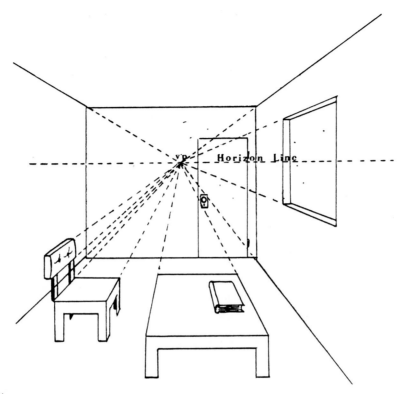

One-point perspective.

Below is a diagram of a room drawn in two-point perspective. Study it closely.

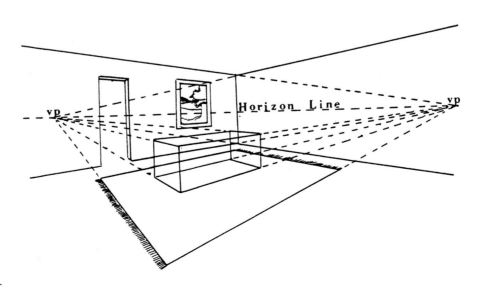

Two-point perspective.

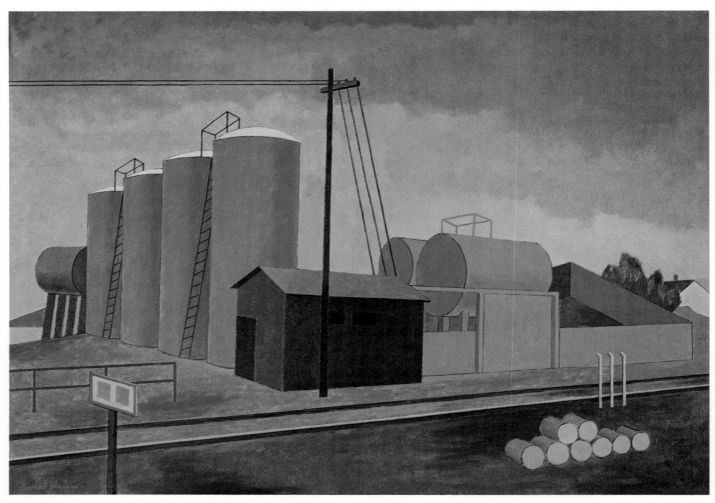

Niles Spencer. *Across the Tracks.* 1935. Oil on canvas, 35⅜" x 49⅜". James and Mari Michener Collection, Archer M. Huntington Art Gallery, The University of Texas at Austin.

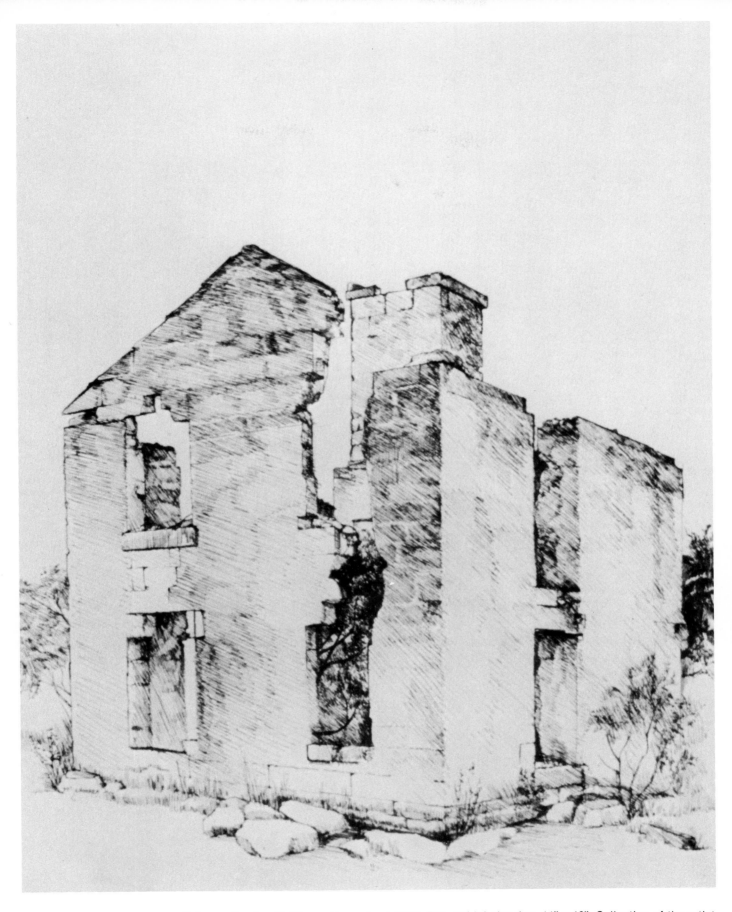

Rebecca Brooks. *McKinney Homestead*. 1976. Pen and ink drawing, 14" x 12". Collection of the artist.

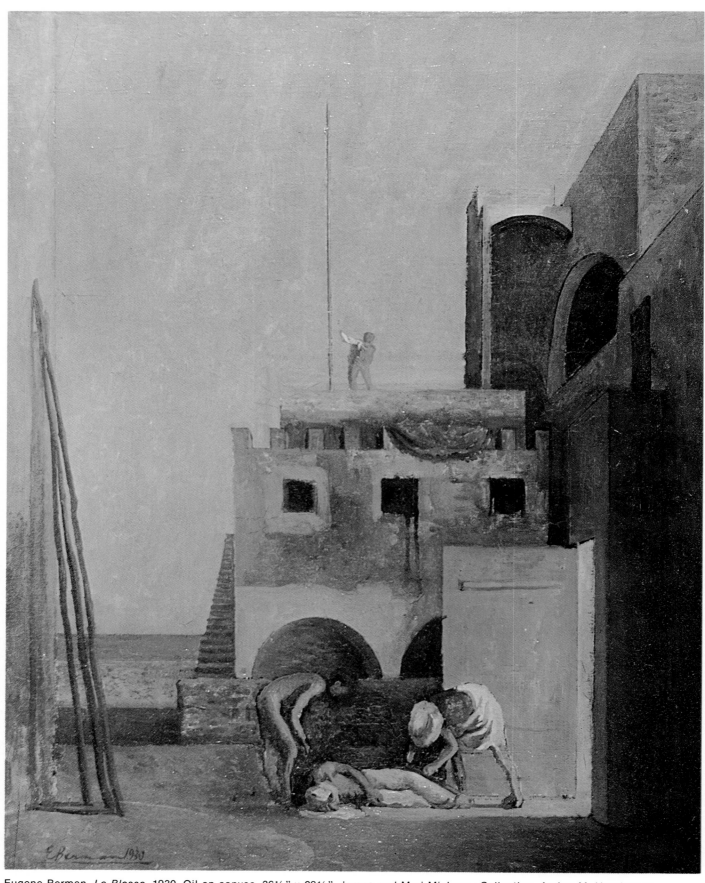

Eugene Berman. *Le Blesse*. 1930. Oil on canvas, 36½" x 28¼". James and Mari Michener Collection, Archer M. Huntington Gallery, The University of Texas at Austin.

PERSPECTIVE: MAKE YOUR MARK!

1. Draw a street scene in either one- or two-point perspective. Include cars, buses, and trucks. Draw lightly the blocks for the cars and trucks. Sketch the shape within the box. Now, "chip" away (erase) the lines. Make buildings, cars, trucks, and buses look "real" by not using shading.

2. Draw a room using one- or two-point perspective. Draw furniture, pictures, rugs, lights, etc. to add reality to your picture. Try drawing the inside of a hospital, hotel, gym, school, movie theater, cafeteria, or your room.

Student work.

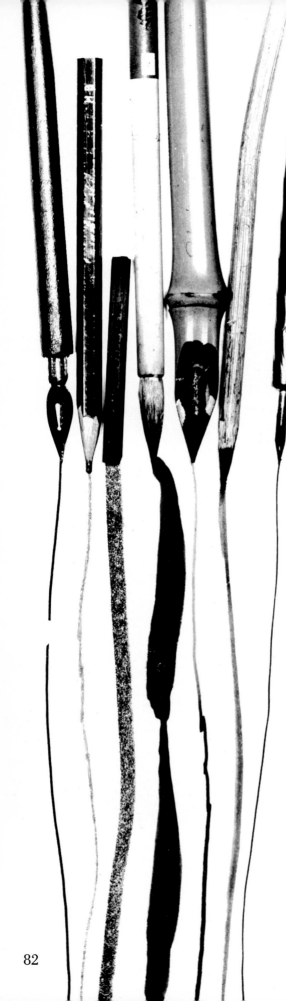

MATERIALS

Part of the fun of making art is working with different materials. Since there are so many kinds of art materials, you can choose exactly the tools necessary to express any idea you may have. Of course, some materials are better than others for certain art activities. The following list, though far from complete, may help you choose which materials would be better for your particular idea. However, always feel free to experiment with art tools and techniques. That is part of the excitement and challenge of making art. Who knows, you may discover something completely new!

PAPERS

Newsprint
This paper is good for quick drawings in charcoal, pencil, chalk, crayon, but not very good for "wet" inks and paints.

Construction Paper
This is good for pencil, charcoal, crayon, chalk, ink; it works well with colored chalks and crayons, but may wrinkle when being painted with tempera. It may be substituted for watercolor paper when that is not available.

Charcoal Paper
This can be an expensive paper. It comes in white and several other colors and usually has a slightly textured surface. This paper is good for quick sketches and more detailed drawings in charcoal, pencil, chalk, crayon, and ink.

Watercolor Paper
Usually a rather expensive paper, it is described and sold by "pounds" (the more pounds, the heavier, thicker, and more expensive the paper). For example, "400-pound" watercolor paper is very good, but very expensive, whereas "90-pound" paper is adequate for most beginning artists. Watercolor paper can be used with watercolor, tempera paint, or ink. It may have a smooth or textured surface.

Drawing tools, left to right: steel blunt-tipped ink pen; carbon pencil; conté crayon; Japanese watercolor brush; reed ink pen; stick pen; steel, crowquill ink pen.

DRAWING TOOLS

Pencils

The ordinary #2 lead pencil can produce very nice drawings. However, you may want to try "real" drawing pencils. *Soft* drawing pencils (6B to 2B) can be found in many art and craft stores, even in some supermarkets. Pencils are good for both quick sketches and detailed drawings. They work on almost any surface.

Charcoal

Charcoal comes in sticks called *vine* and *compressed*. It comes in several degrees of thickness and hardness. It is very good for quick sketches and shading (developing a three-dimensional quality through the use of *value*). By using the side of the charcoal stick, thin lines as well as wide strokes can be made.

Pen and Ink

There is a wide variety of pen types from which to choose. "Crowquill" pens usually come in two parts—*staff* and *nib* or pen point. You can choose from a wide selection of points varying in the width of the mark each makes. Many can be used for lettering. Pens are good for sketching or making detailed drawings. Inks come in a variety of colors—black India ink, brown, white, red, blue, etc. To draw with the crowquill pen, you must dip the pen point into the bottle of ink each time you make a mark. Since this seems to some to be an "old-fashioned" way to draw, other types of drawing pens have been invented. The *cartridge-type pens* make repeated dipping unnecessary. Remember to use caution with India ink. It will not wash out of clothing!

Ball-Point Pens and Felt-Tip Markers

These drawing tools are inexpensive and easy to find in supermarkets and school stores. They are very good for quick sketches or more detailed drawings. Felt-tip markers can be used to create two interesting drawing techniques: *hatching or cross-hatching* and *stippling*. Hatching or cross-hatching is a method of shading objects or creating *value* with ink. Since it is almost impossible to blend and smooth ink used with a pen, an artist must build up *value* with *line*. Hatching is the repetition of lines to create a dark area. The more lines drawn, the darker the shadow. Stippling, sometimes called *pointillism*, is similar to hatching. It is used to build areas of shading. In place of the line, a dot or point is used. The closer the dots, the darker the area.

Caution: India ink is permanent and will NOT wash out of clothes.

Caution: Some felt-tip markers and ball-point pens are permanent and will NOT wash out of clothes.

Crayons

Crayons are inexpensive and good for both quick sketches and detailed work. Wax crayons make a good substitute for the more expensive oil pastels. Color mixing and blending are possible with practice.

Pastels

Pastels can be used like wax crayons for sketching and more detailed work. The more expensive sets of oil pastels and chalk pastels come in a beautiful range of colors. They are easy to blend and smooth. A spray fixative must be used to prevent chalks from smearing once a drawing is complete.

Tortillon

This is a tightly rolled stick of paper. It may be purchased or made by wrapping the end of a pencil with a piece of paper towel. Tortillons are excellent for blending pencil, charcoal, or pastels. Since the tortillon is pointed, even details in a drawing can be blended easily.

Erasers

Erasers are usually inexpensive and useful for more than removing mistakes! *Gum* and *kneaded* erasers are the types most frequently used in art. However, plain pencil erasers also work well. A handy addition to an eraser collection is a typewriter eraser—the kind shaped like a pencil with a brush on one end. These erasers can be sharpened like pencils, making them excellent tools for "pulling out" areas of light. This technique of "drawing" with an eraser creates very interesting effects with light and shadow.

PAINT

Tempera

This paint is inexpensive and can be thinned with water. It comes in a variety of colors which mix together easily. Tempera paint works well on most paper. It can be applied with brushes, pieces of cardboard, sponges, or a printer's *brayer* or roller. Tempera paint will crack if applied too thickly.

Watercolors

Watercolor is different from tempera in that it is *transparent*. Watercolors are thinned with water like tempera paint. Watercolors work best on real watercolor papers, although white construction paper can be substituted. Interesting effects are achieved by first dampening paper, then applying watercolor. The colors will "bleed", creating shapes resembling plants, trees, clouds, or whatever you imagine!

Acrylic Paint

Caution: Acrylic paint will NOT wash out of clothes.

Acrylic paint is expensive but excellent for a number of painting effects. The base ingredient of acrylic paint is a plastic. This prevents the paint from cracking like tempera, even when applied thickly. Acrylic paint can be applied with brush, sponge, cardboard, or a *palette knife*. Although acrylic paint is thinned with water during use, brushes must *not* be allowed to dry with the paint in them. Unlike tempera, acrylic will not wash out of brushes or clothes if allowed to dry. Be careful!

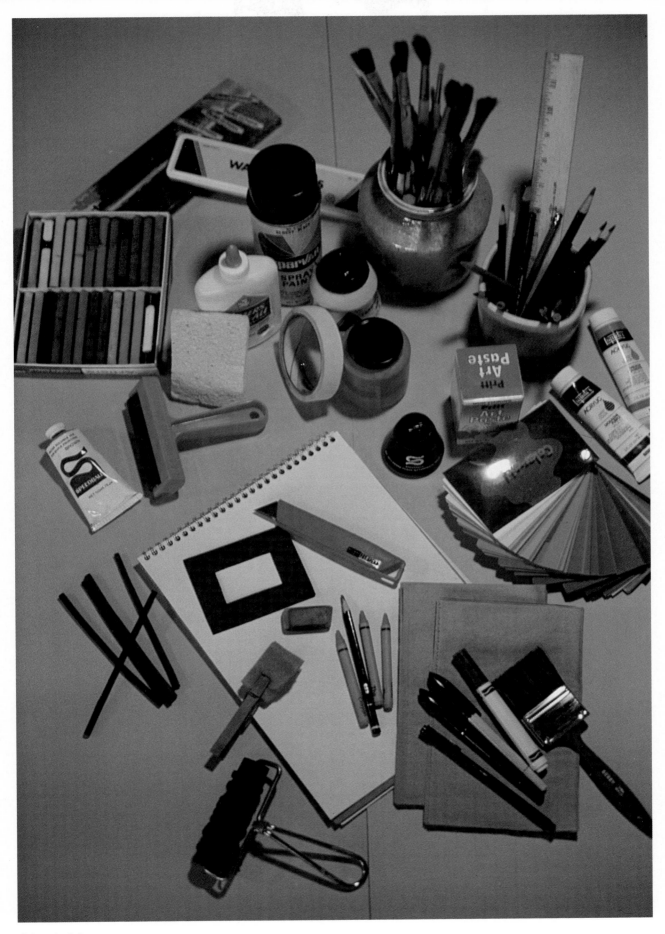

Art materials.

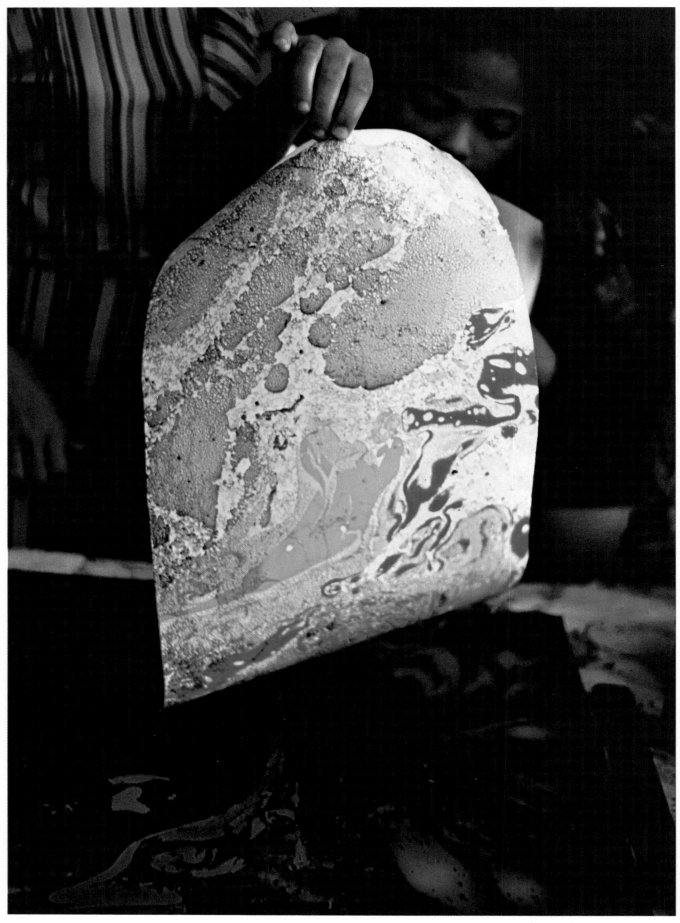

Lifting marbleized paper from the paint-saturated surface of a shallow tray of water.

SPECIAL TECHNIQUES

Pencils, crayons, tempera paint are fine for creating many different kinds of art. Sometime experimentation with materials and techniques stimulates your imagination and helps you to express your ideas in new and exciting ways. Below are some techniques you will want to try either on your own or with your art teacher's help. Because these are special techniques, you may want to select the subject for your art work *after* you see what happens!

Remember, these processes give you ideas for drawing and painting. However, each technique is only the beginning. You will want to draw or paint *into* each work to make it truly yours. Enjoy and let your imagination take control!

MARBLED PAPER

The technique of marbling paper, invented in the 16th century, is easy and the results are spectacular!

Materials

old cookie sheet or aluminum roasting pan (supermarkets have these)
several colors of oil-base paint
turpentine
small cans or jars
sheets of white and colored construction paper
newspaper to cover your work area (this can get messy!)

Caution: Use turpentine and oil-base paint in a well-ventilated area. Turpentine and oil paint fumes can be dangerous.

The basic idea behind this exciting technique is to float thinned oil paint on top of water in a wide, shallow pan. By laying a sheet of paper on the surface, you pick up whatever patterns of color are on the water at that time. The designs are never the same. When dry, your marbled sheets can be drawn on with a variety of materials, such as pen and ink, felt-tip markers, watercolors, or crayons. The beautiful colors and patterns suggest many ideas for drawing in the undersea world, outer space, mystical landscapes and strange creatures.

Another method uses powdered colored chalks in place of the thinned oil paint. Small pieces of chalk can be ground up and sprinkled on the surface of the water.

CARBON PRINTING

You probably think carbon paper is used only for making copies in a typewriter. However, interesting art can be created with carbon paper, drawing paper, and an iron!

Materials

several sheets of carbon paper (black, blue, or other colors)
white drawing paper
an old iron (do not use your mother's iron without permission!)
sheets of newsprint

Place several sheets of newsprint on a table (an *old* table, not good furniture). The iron should be set on medium heat. Tear your carbon paper into several shapes, crumple each shape, unfold and place *carbon side down* on the sheet of drawing paper. Place a sheet of newsprint on top and iron. The heat of the iron will transfer the carbon to the drawing paper in wild and complicated patterns. The longer you iron, the darker the print, but do not burn the paper! You should keep the iron moving at all times.

The results of your carbon printing will suggest a variety of images to you. Vines, roots, trees, plants, animals, all emerge from the paper. Work into your creation with pen and ink, markers, crayons, or watercolors.

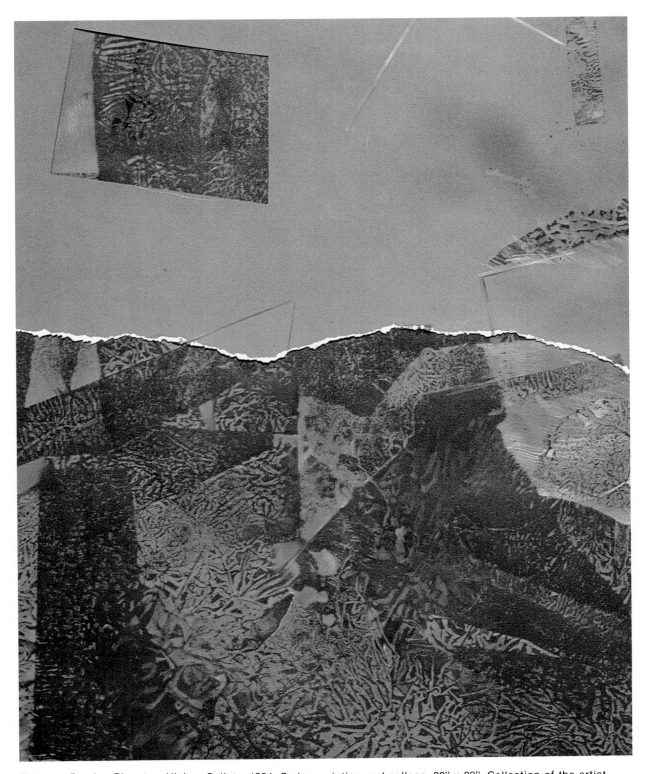

Rebecca Brooks. *Planetary Vision: Calisto.* 1984. Carbon printing and collage, 22" x 28". Collection of the artist.

SCRATCHBOARD

By preparing a special drawing surface with white paint or crayon, India ink, and white poster board, an interesting drawing can be made without using a pen or pencil at all. This special surface is called a *scratchboard*. As the name suggests the image is made by "scratching" through a layer of India ink into the white paint or crayon beneath. The lines of the drawing will be white rather than black.

Materials

white poster board
white acrylic paint (left-over white house paint works great)
or white crayon
black India ink

Caution: Acrylic paint and India ink will stain clothes.

Prepare your scratchboard by painting two or three coats of white acrylic paint on the white poster board. White crayon can be substituted for the paint if applied heavily. After the paint dries, cover the surface with one or two coats of India ink. When the ink surface dries you may begin your drawing. A light pencil sketch of your subject is made on the scratchboard surface before you begin scratching the image.

Caution: Use sharp-pointed tools with care.

Many objects will serve as tools for scratching away the ink—nails, compass points, scissors. You will find that just as in a pen and ink drawing, *hatching* with line builds areas of *values*. However, on a scratchboard you are building areas of light reflection rather than shadow.

Scratchboard drawings are more successful if you choose subjects with interesting details and textures, such as birds, reptiles, fish, insects, plants.

COLLAGE/MIXED MEDIA

Adding pieces of paper, photographs, or fabric to your
drawings or paintings, or combining several art materials in one
drawing produces a more unusual and creative work.

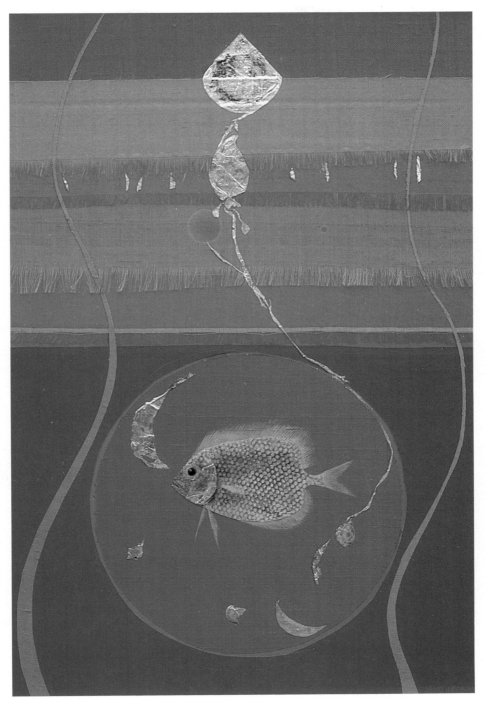

Kelly Fearing. *Orange Around; Fish Collage, 1980, No. 2.* 1980. Collage with Prismacolor pencil drawing, Thai silks and gold leaf acrylic skins, mounted on Color-Aid paper, 17¾" x 11¾". Collection of Dr. Frank Lee, Wichita Falls, Texas.

A *collage,* which combines various materials, such as paper, photographs, or fabric can be used as a background for a drawing or painting. Remember to save bits of fabric scraps, wallpaper, colored tissue paper, wrapping paper and greeting cards. They all can be used in a collage. The surface for the collage materials needs to be rather heavy, such as cardboard or poster board. Attach the materials with glue. Any white glue works fine.

MIXED MEDIA

Often the use of only one art material or technique is not enough to accomplish all you want to express. If that is the case, experiment with a combination of materials and techniques in one art work. For example, look at the work on page 89. The artist combined carbon painting with drawing and collage.

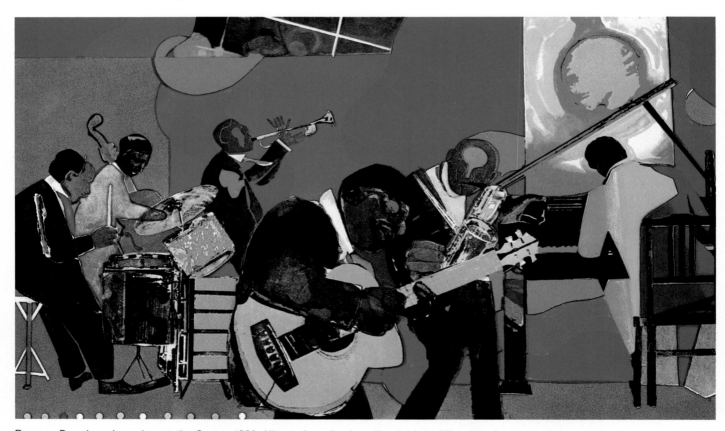

Romare Bearden. *Jamming at the Savoy.* 1982. Nine-color mixed-media etching, 22" x 30". Courtesy of June Kelly Fine Arts, New York. Photo credit: Manu Sassonian.

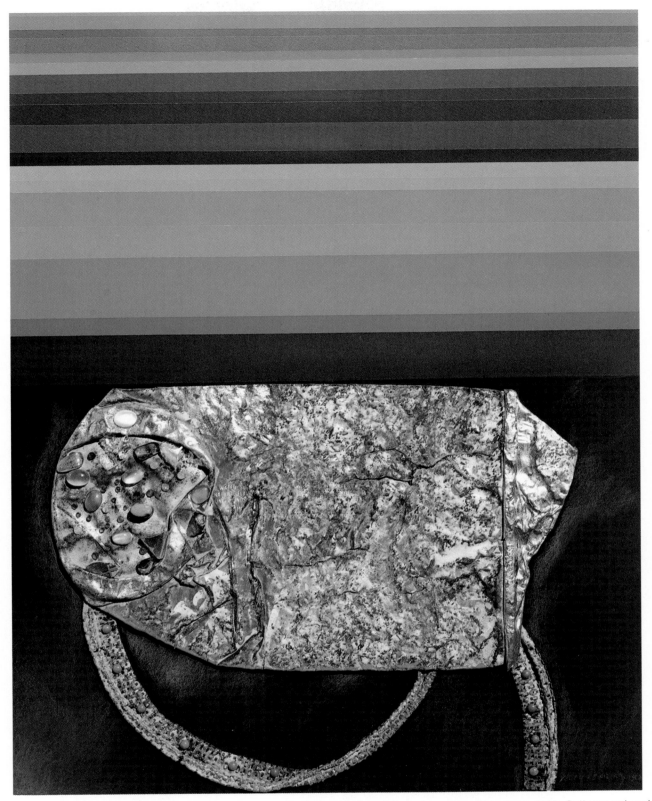

Kelly Fearing. *Chalice for Holding Precious Things: Collage with Street Transformation #9 in 1982*. 1982. Collage: colored pencil, found object from street, precious stones (opals, emeralds, rubies, moonstone, mother of pearl, jade, turquoise, mirrored crystal, coral, amber), gold leaf, Color-Aid paper. 11¼" x 9". Collection of the artist.

RENDERING

Examine works on the following pages. Each artist has drawn, painted, or *rendered* objects in great detail. In fact, the objects appear so real that you might believe they are photographs rather than drawings or paintings!

If you want to produce this kind of ''realism'' in your own work the following suggestions will be helpful.

1. Select a ''real'' object as your subject, *not* a photograph of the object.

2. Examine and study the object carefully. Observe how the reflections, highlights and shadows define the shape. Look at the Janet Fish work, ''Vinegar Bottles,'' on page 95. Notice that when drawing or painting transparent glass you must not only show what is *behind* the object or what you see through the glass, but also the highlights, shadows, and reflections on the *surface*. Draw only what you see, not what you think you know! Complicated—yes, but with practice you can do it!

3. It is easier to achieve good results when drawing or painting transparent objects like the vinegar bottles, on page 95, or crystals if you draw or paint on a ''toned'' or colored background. Using a colored rather than plain white paper for a background allows you to use *white* as light. Highlights are an important part of drawing transparent objects. When painting, you prepare your darkened background by covering the paper first with a wash of paint. Colors such as gray, blue-gray, green, or brown work well.

Antonio Henrique Amaral. *Campo de Batalha 31 (Battlefield 31).* 1931. Oil on canvas, 36" x 48". Archer M. Huntington Art Gallery, University of Texas at Austin, Archer M. Huntington Museum Fund, 1975.

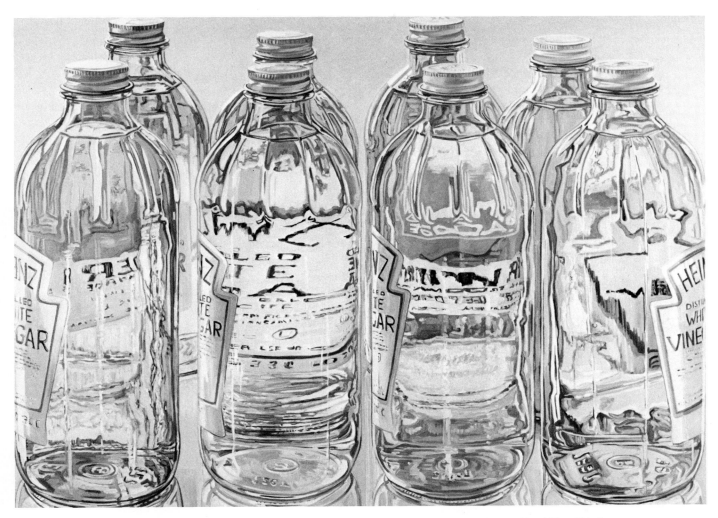

Janet Fish. *8 Vinegar Bottles*. 1972-73. Oil on canvas, 53" x 72⅛". The Dallas Museum of Art, gift of The 500, Inc.

4. Study carefully the shadows or any object you choose to draw or paint. Objects such as rocks, bottles, vegetables are three-dimensional. They have volume and occupy real space. To draw them convincingly you must use shading. If you begin your drawing by using a heavy line around the edge or contour, you will *not* be able to create a "realistic" drawing. A heavy outline "flattens" the image of the object. Even if you later add shading, the outline will still show, destroying the "illusion" of reality you are trying to achieve. Look again at the works on these pages. Notice that there are *no* heavy outlines. All objects are smoothly shaded and highlighted. They convince us that they occupy a real space and are three dimensional.

5. *Practice, practice, practice!* Yes, that really is the only way to learn to draw and paint in a realistic manner. At every opportunity you should sketch objects from a variety of object changes when light strikes them from different directions. If you *observe* and *practice* you can become very skillful at creating an "illusion" of the three-dimensional world in your art.

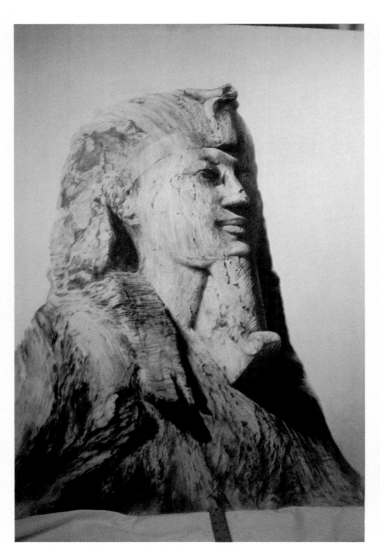

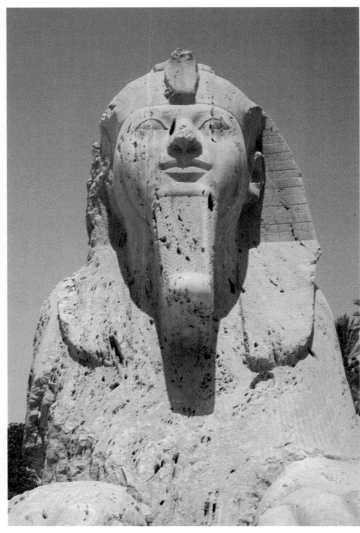

Rebecca Brooks. *Sphinx*. 1980. Pencil drawing, 30" x 40". Collection of the artist.

Alabaster Sphinx. Sphinx of Ramses II. 19th Dynasty, New Kingdom. Saqqara, Egypt.

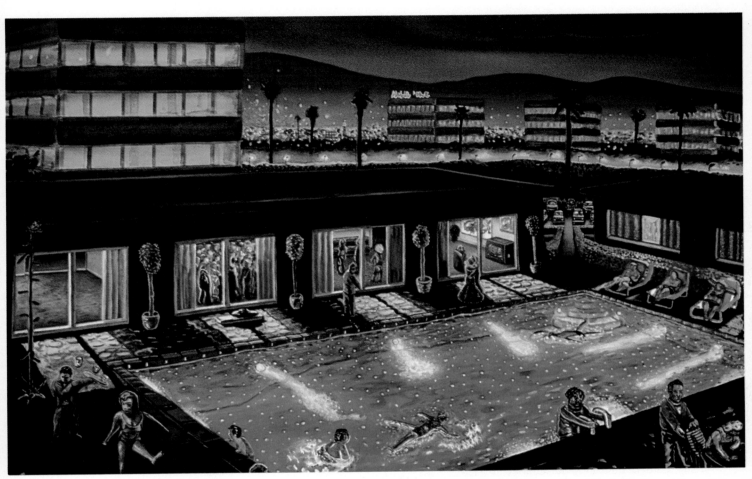

Robert Yarber. *Night Pool*. 1980. Oil on canvas, 45" x 60". Collection of the artist.

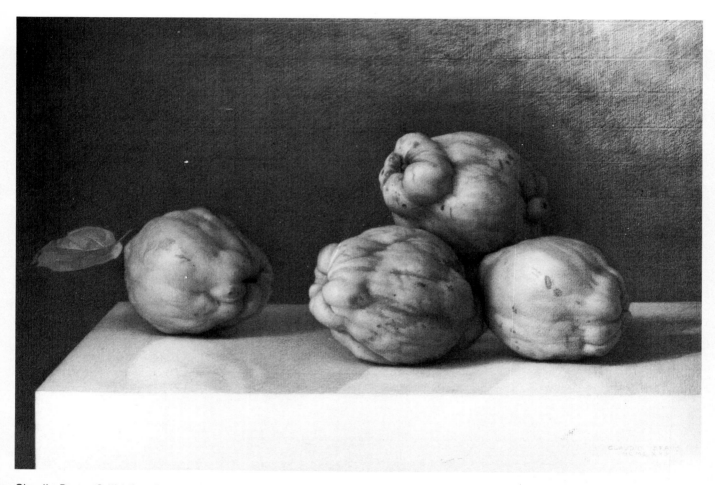

Claudio Bravo. *Still Life.* 1980. Graphite on rag paper, 14¼" x 20⅝". Archer M. Huntington Art Gallery, The University of Texas at Austin, Barbara Duncan Acquisition Fund, 1980.

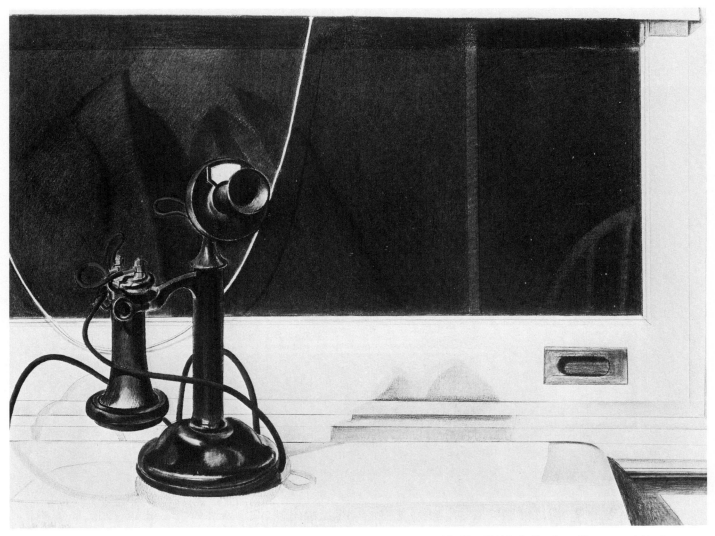

Charles Sheeler. *Self-Portrait*. 1923. Conté crayon, gouache, and pencil on paper, 19¾" x 25¾". Collection, Museum of Modern Art, New York. Gift of Abby Aldrich Rockefeller.

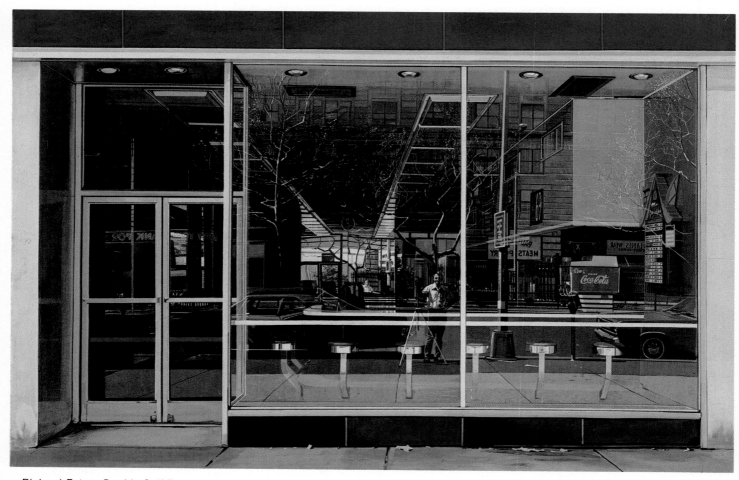

Richard Estes. *Double Self-Portrait.* 1976. Oil on canvas, 24" x 36". Collection, The Museum of Modern Art, New York. Mr. and Mrs. Stuart M. Speiser Fund.

MATERIALS AND SPECIAL TECHNIQUES:
MAKE YOUR MARK!

1. Using large sheets of newsprint and charcoal make several quick sketches of figures in action. You might ask a family member or friend to pose in different positions pretending to be:

> throwing
> kicking
> reaching
> batting
> playing
> running

Time each pose allowing no more than 30 seconds or a minute for each.

2. On a large sheet of colored construction paper make a full-color drawing of an animal. Work from sketches or photographs made at the zoo or of family pets. Blend chalk or crayon to create the realistic color and patterns of the animals. Indicate details such as fur, scales, wrinkled hide. Use white crayon or chalk for highlights. Create an environment for your animal—jungle, desert, or forest.

3. Collect the pieces of colored chalk which are too small to use in a drawing. Grind the pieces to dust by rubbing them over course sandpaper or over an old cheese grater. Keep each pile of dust separate. You might collect each color in a section of an old cupcake pan. With a piece of white or colored construction paper create a stencil design using cardboard cutouts of your initials. Place the cardboard letters on the construction paper and smear the powdered chalk over the edges, around each letter.

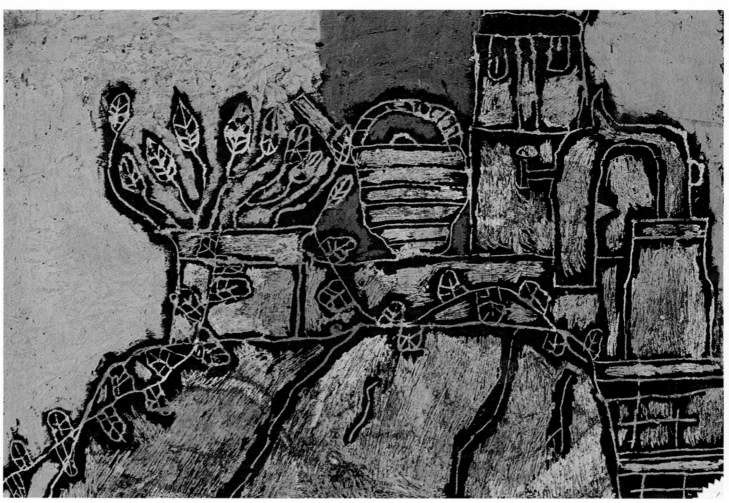

Crayon etching by student.

4. The next time you are outside on a sunny day try the following drawing project. Taking a large sheet of drawing paper, crayon or pencil, place your paper on the ground near an object that is casting a shadow. Capture the shadow's image on your paper by outlining the shadow in pencil or crayon. Combine several shadow images on the paper. Later fill in the shadow images with bright colors in crayon or colored chalks. You will find interesting shadows cast by bicycles, branches, fences, lawn furniture, and playground equipment.

5. Make a watercolor painting of a remembered time or place when it was raining. Try to capture the mood and your feelings at the time. Dampen the watercolor paper with a sponge or brush. Apply watercolors to the wet paper, letting them run and blend together.

6. Paint a foggy landscape. It may be a dense fog, obscuring details of the distant view, or a light mist. In either case, try to capture the mood that such a foggy landscape would create. Use your watercolors with brush and sponge. Apply heavy color in a broad band at the bottom of your paper. Holding your paper upside down, allow the color to run. By this method, you will create the look of bare wet winter trees or swamp plants.

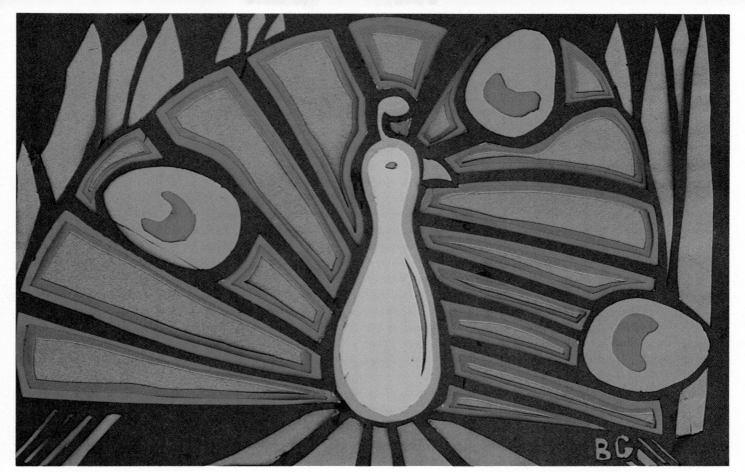

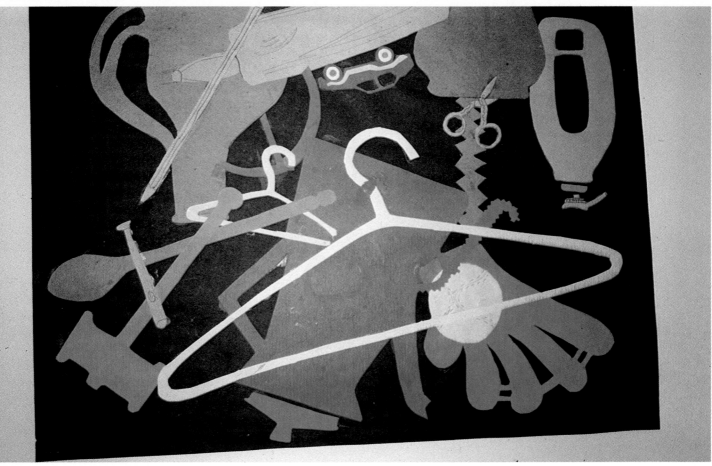

above. Collages by students.

7. Select a simple three-dimensional object, such as a cup, tea kettle, or coffee pot. With a pencil, make a light sketch of the object. Using a crowquill pen and India ink, *without outlining the edge*, create the shape by the "hatching" technique described on page 83. It might be wise to practice hatching on a piece of scrap paper. It takes practice and patience to achieve a smooth transition from deep shadow to bright highlight.

8. Make a drawing of the same object or another with the "stipple" or pointillism technique. This time use a felt-tip marker. You may *lightly* sketch the object in pencil first. But, remember *not* to outline the edge! In fact, no *lines* should be used at all. The shadows and form of the object are created by adding more and more dots.

9. *Logo* is a term which describes a design using letters, numbers, or shapes which represent or symbolize something or someone. Many companies and large corporations have logos that symbolize their name or their products. From your own initials, create a design or *logo* for yourself. Think of several ways to combine your initials into an interesting design. How can you make the letters express something about your own personality, hobbies, or interests?

10. Cover a sheet of white construction paper with a coating of charcoal. Smear the charcoal with a cloth or paper towel until a soft gray *value* covers the entire sheet of paper. With gum, kneaded or sharpened typewriter eraser, *erase* a drawing! Instead of drawing with a pencil, charcoal, or pen, use your eraser to make the drawing. You might choose a landscape or seascape as your subject. All lines and values are made by "pulling" out or erasing the charcoal background. Your objects will be white or light gray, standing out against the darker background. Notice how this technique creates a definite mood.

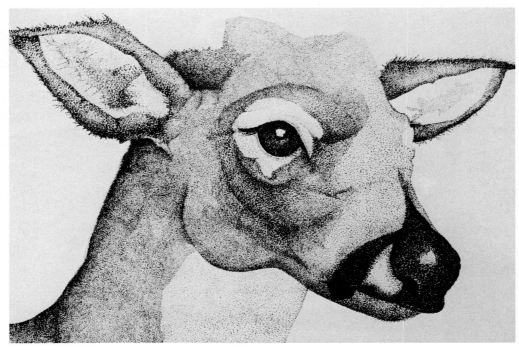

Student work in pen and ink. Pointillism technique.

Student work in felt-tip markers. Pointillism technique.

11. Imagine that your eyes have the ability to see an object in greater and greater detail each time you look at it. Every glance brings it ten times closer with ten times more detail than before. Select something like a piece of driftwood, shell, or leaf. Divide a sheet of drawing paper into six sections. In each section lightly sketch, then paint your object, but viewed ten times closer. In other words, each section will reveal a *magnified* view with more detail. Can you imagine what its cell structure would look like? Save this view for the final section. If you have a microscope available at home or at school, you can use what you see through the microscope to give you many interesting ideas for drawings and paintings. Amazing images can result from magnifying ordinary objects.

Caution: Acrylic paint stains clothes.

12. Make a painting in tempera or acrylic paint *without using a brush*. Apply background colors with a piece of cardboard, sponge, or printer's brayer. When the background is dry, add objects, figures, animals, architecture, or landscape details with cardboard, sponges, sticks, string, your hand! Use anything *but* a brush. Keep in mind how a particular color scheme can create a mood or special feeling in your work.

Caution: Use turpentine and oil-base paint in a well-ventilated place.

13. Use the marbling technique described on page 87. Make several sheets of marbled paper. Let the swirling patterns and colors of the technique suggest drawing and painting ideas to you. Maybe one piece of marbled paper looks like a shallow pool at the sea's edge. Complete the idea by drawing in crayon, chalk, or colored pencil the images of starfish, small crabs, rocks and shells caught in the tidal pool. Try not to draw *against* designs and patterns of the marbling. Use the curves, dips, and twists of the colors to form your images. Another marbled sheet may suggest a strange, alien landscape with unusual rock formations and vegetation. Emphasize this image by working back into the marbling with paint, crayon, chalk, or colored pencil. You may want to "block out" a large area for "sky". Using tempera or acrylic paint, simply paint out the marbled pattern you do not want. This will create a horizon line between your painted sky and the "marbled" landscape. Complete your work with "alien" objects, figures, or creatures.

Student work in crayon.

Example of student work in carbon printing technique.

14. Experiment with the carbon printing technique described on page 88. You may see strange plants or animals in your completed prints. Bring these images out by working into the print with pen and ink, felt-tip marker, or ball-point pen. With practice you can learn to control the carbon printing technique. Images can be cut from carbon paper, arranged and printed to create recognizable animals, figures, or objects. Trying for more control, create a dragon using cut or torn pieces of carbon paper to represent parts like head, body, legs, and tail. Arrange the pieces on your drawing paper to make the image of the dragon. Do not forget to wrinkle the carbon paper first—then iron. You should get a fantastic dragon with very wrinkled skin or scales! Add more details with markers, pen and ink.

15. Prepare a scratchboard according to directions on page 90. When your scratchboard is dry, lightly sketch in pencil the image of a plant. Use real plants and flowers as subjects. Examine the details carefully before drawing. Using hatching, scratch the image with a nail, compass point, or paper clip. Do not outline! Build the highlights with the hatching lines. The more scratched away, the lighter the area. Include details of the plant—shape of leaves, leaf and stem textures, flower shape.

16. Create a "miniature" collage on a piece of cardboard or poster board no larger than 3 by 5 inches. Use as material for your collage an unlikely collection of gum wrappers, grocery lists, ticket stubs, and candy bar wrappers. Both cut and tear the paper to create interesting edges. You do not need to create a recognizable "picture" of anything. Simply use the bits of paper to create an interesting composition. As you construct your collage remember the *design principles* introduced in Volume One. Does your composition have *unity*? Is it balanced *symmetrically* or *asymmetrically*? Is there *variation* among shapes?

17. Combine several materials or techniques in one art work. Begin with a process such as marbling, carbon printing, or watercolor and let the process suggest ideas to you. Emphasize images by drawing into your work with crayons, chalk, ink, or other materials. *Experiment*!

18. Collect a number of empty clear glass jars or bottles. On a piece of dark-colored construction paper, render or draw your collection as realistically as possible. Use colored chalks or crayons. Added interest is achieved by using bottles or jars which, though transparent, have some color—green, brown, or blue. For a real challenge, place a collection of small objects *inside* a clear glass container. Make a detailed pencil or charcoal drawing of the subject. You might fill a large jar with marbles, shells, nails, or small toys.

CHAPTER IV

LOOKING OUT:
ARCHITECTURE AND TECHNOLOGY

ARCHITECTURE

Man's earliest form of architecture was probably no more than a sheltering cave. Yet, the need to *design* and *build* structures for shelter, governance, and ceremony seems a basic and important part of man's creative nature. As early man wandered about searching for food, the need for more portable structures grew. These structures may have consisted of tree branches with a grass or leaf covering. Eventually settlement groups developed into clans, villages, towns, cities. More than simple shelters were needed. In an effort to assign importance to the centers of government and religion, impressive permanent structures were necessary. The planning and building of a structure such as that pictured on page 111 takes the talent and commitment of many individuals. Examples of monumental architecture from the ancient world, such as those shown on pages 111-113, speak clearly to us across the centuries of that talent and commitment. Indeed, even today the construction of many ancient buildings and monuments, with but primitive tools and building techniques, seems miraculous.

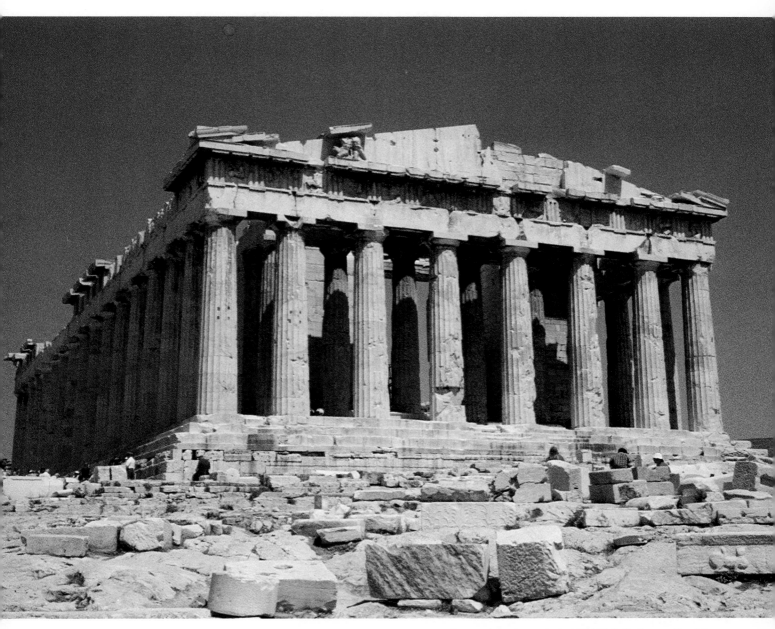

The Parthenon, west facade. Greek: Classic period, 448-432 B.C. Acropolis, Athens.

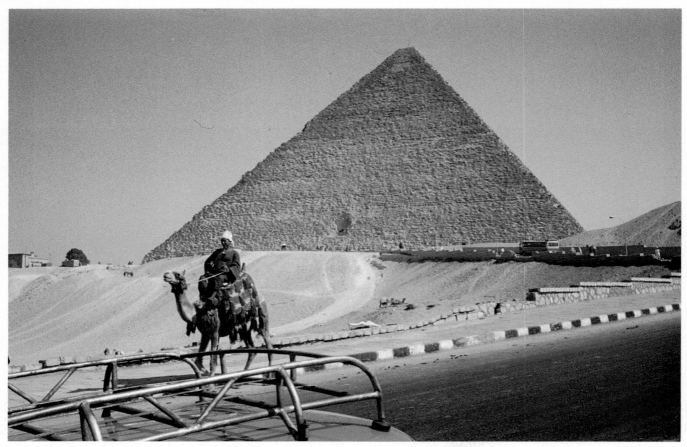

Egyptian. *Pyramid of Cheops.* c. 2670 B.C. Giza.

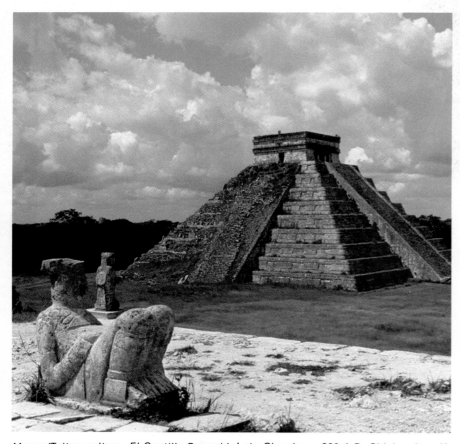

Mayan/Toltec culture. *El Castillo Pyramid.* Late Classic, c. 900 A.D. Chichen-Itza, Yucatan.

112

Just as painters and sculptors are inspired by the forms of nature, so too are architects. The shape and decoration of numerous ancient structures were inspired by natural forms. For example, many ancient civilizations considered hills or mountains to be the "place" or "home" of their gods. From this inspiration the *pyramid* structure probably was developed. Both the civilizations of early Egypt and of Mexico used the pyramid form with variations. Look at the pyramids on page 112. Can you see the differences?

Important buildings were often placed in such a way that the movements of the sun, moon, and stars became part of the symbolism and meaning of the structure. The circle of stones shown below is known to the world as *Stonehenge.* Built around 1900-1400 B.C., it is considered by some scientists to be an example of an astronomical observatory. Many of the large stones and arches of Stonehenge are aligned with astronomical events which take place throughout the year. Quite an achievement for men with only bones, wood, and stones for tools!

While history is filled with examples of monumental structures from many civilizations and cultures like those pictured on the following pages, modern architects continue this tradition of monumental structures.

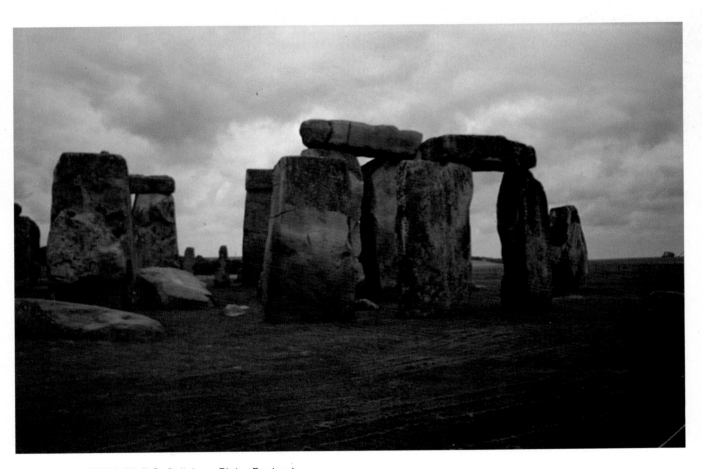

Stonehenge. 1900-1400 B.C. Salisbury Plain, England.

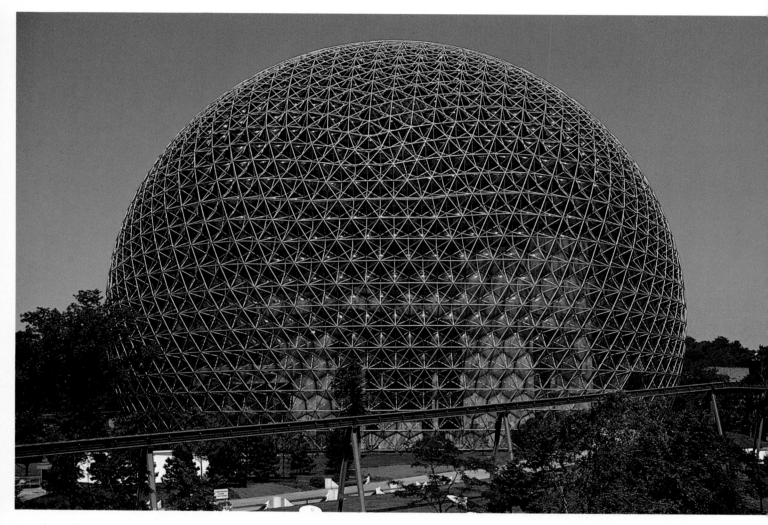

above. R. Buckminster Fuller. *U. S. Pavilion, Expo. 67,* Geodesic dome, 250' d. and 200' h. Montreal, Canada. Credit: Peter Arnold, Inc.

The *Geodesic* dome pictured above was designed by American architect Buckminster Fuller. This imaginative structure is an example of how modern architects take advantage of new materials and building techniques. It is now possible to construct buildings almost entirely of glass.

With the development of *reinforced concrete* in the late 19th century, contemporary architects were truly able to give form to their most imaginative ideas.

The Opera House in Sydney, Australia, takes advantage of the possibilities of modern building materials. As with many ancient structures, this beautiful building was designed to reflect the location or setting. The bold form of the roofs was designed to remind viewers of the white sailboats in the harbor.

Although many examples of architecture from the past and present impress us with their monumental size, few of us would want to *live* in such structures. Most architects realize that the *scale* of a building, or its size in relation to human beings, is an important consideration. Airports and sports stadiums need to be spacious since they are designed for thousands of people. In our homes, schools, and offices, we want adequate space. However, we do not want to feel lost!

This is just one of hundreds of details an architect must consider when designing private homes, apartments, schools, and offices. In fact, successful architects need to know as much about people as they do about building materials and techniques.

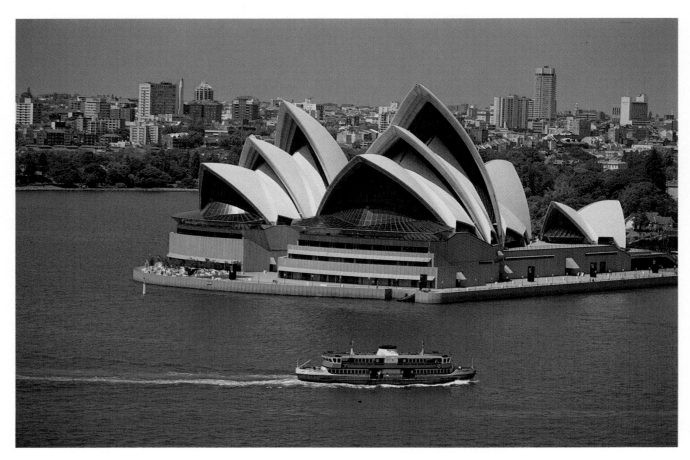

Opera House, Sydney, Australia. Credit: Peter Arnold, Inc.

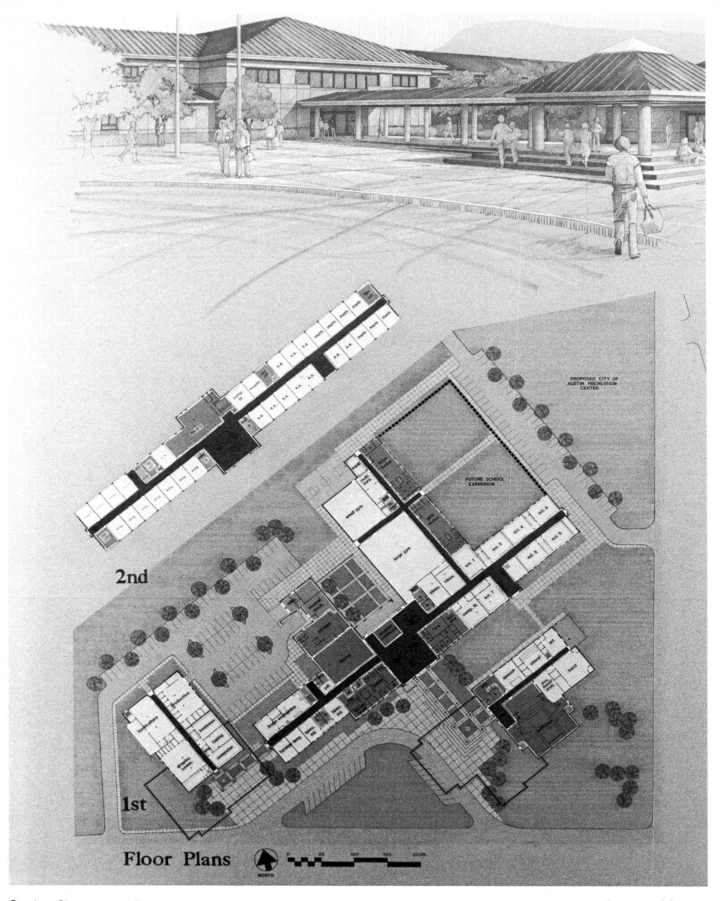

2nd

1st

Floor Plans

Graeber, Simmons and Cowan Architects. *Design for Southeast Junior High School.* Completion date, fall, 1987. Concrete slab, steel frame, metal roof, Cordova Cream/Leuders limestone exterior. 178,000 sq. ft. Austin, Texas.

Have you ever thought about the design of your house, apartment, or school? Do you think your house or apartment is designed on a "human scale"? Is there any part of your house or apartment that seems to be a pattern or design borrowed from the past?

Almost every town and city is made up of buildings from different times and architectural styles. You may have noticed in your neighborhood houses with elaborate wood patterns and decorations on porches, doors, and windows. Many of these houses were built in the early part of the 20th century. At that time people wanted their houses, clothes, and furniture to be decorated as much as possible. Many of these houses have fallen into ruin. However, some people see the beauty of their original design and restore them to their former glory. The saving of these buildings from the past may become a community effort. Have you seen houses in your community that are being restored?

While we cannot all visit the great structures and monuments of the past or present, we can often find in our own neighborhoods examples of architecture reflecting other times and periods. Take time to discover the beauty of architecture in your community.

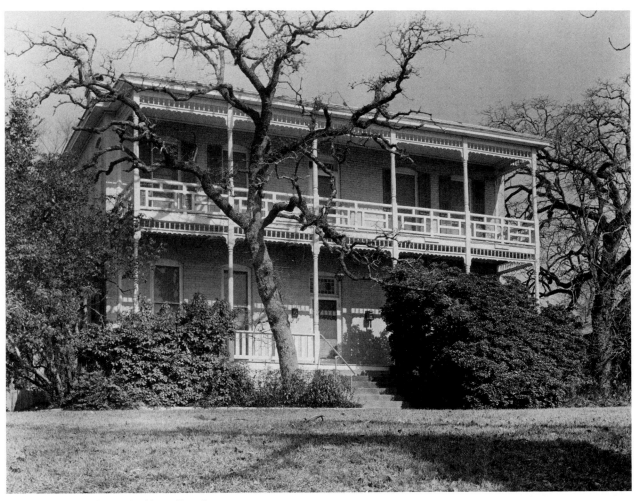

Victorian house. Photo by Hans Beacham.

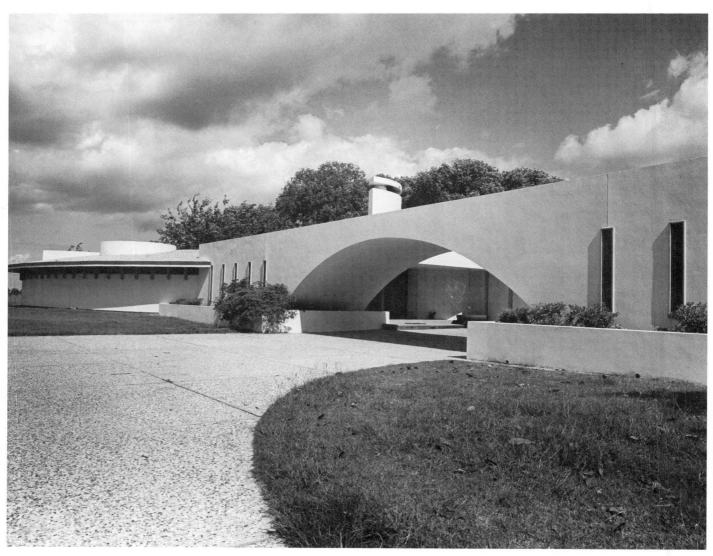

Contemporary architecture. John C. Watson, Architect.
Photo by Hans Beacham.

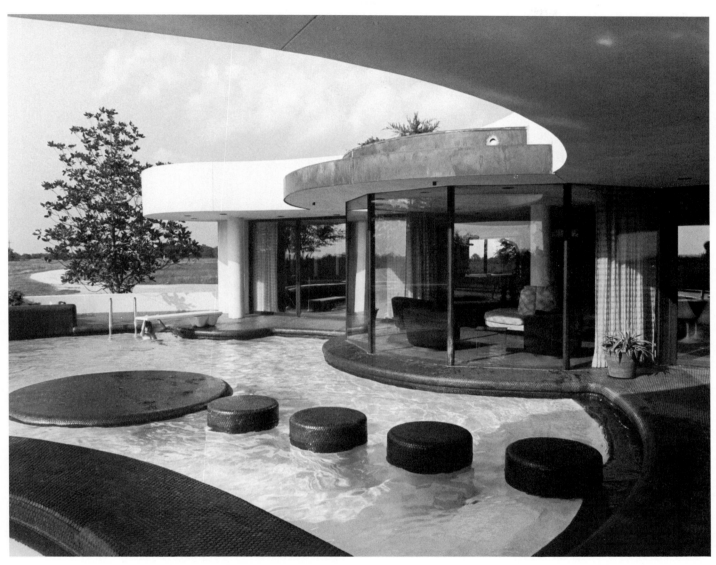

Contemporary architecture. John C. Watson, Architect.
Photo by Hans Beacham.

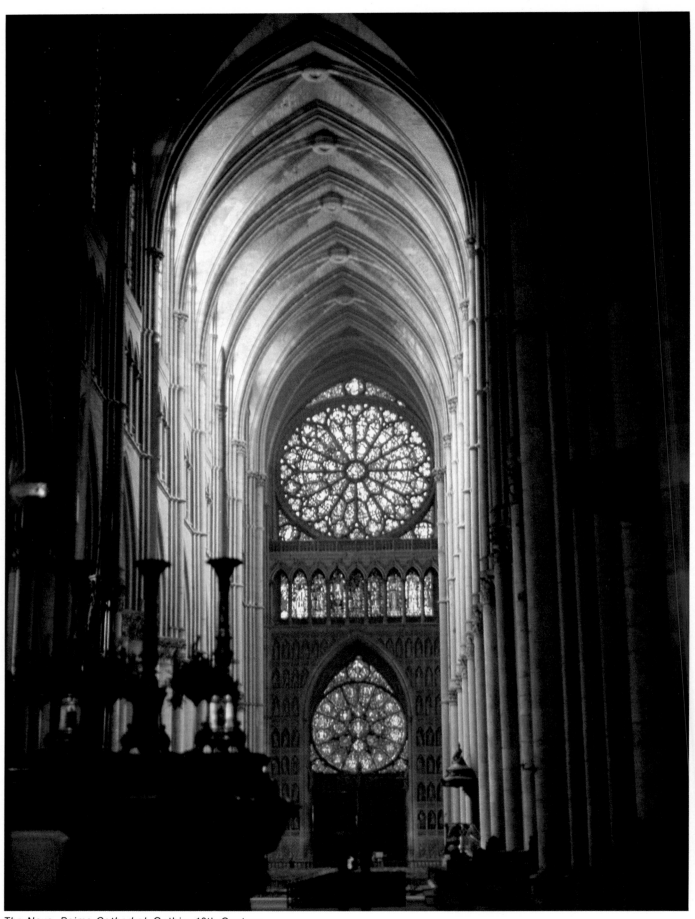

The Nave, Reims Cathedral. Gothic, 13th Century.

TECHNOLOGY

Although most artists continue to use traditional art materials and techniques to express their ideas, modern technology offers many unique and exciting opportunities for creating new art forms. Photography, film and video production, computer graphics and animation offer new challenges for artists of today.

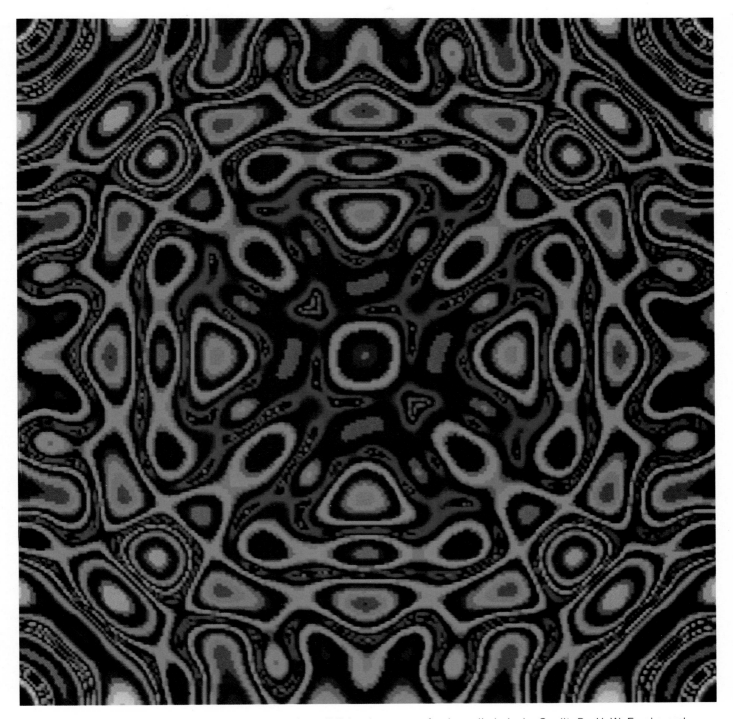

Computer designs like the one above are made up of small lighted squares of color called pixels. Credit: Dr. H. W. Franke and Horst Helbig—Peter Arnold, Inc.

Photography

In our daily lives we are bombarded with huge numbers of photographic images. It is difficult to imagine a world without the photograph to inform and entertain us. Photographs are a valuable source of ideas and information about the world. In many cases, they provide our only reference for how something looks. For example, few people travel to the moon, yet photographs of the moon's surface rocks and craters can be used to inspire and direct us in representing, through art, just how such a visit would appear.

Like paint, clay, and stone, photography also offers artists another creative tool through which to communicate their unique view of the world.

Photography as a technical process is only about 150 years old. In the early days photographs were used primarily to record. That is, to make a "picture" record of an event. It was only later that the possibilities of photography as an art form were realized.

Photography becomes an art form when an ordinary subject viewed through the eye of the photographer is transformed into something new. Like any artist, the photographer must *select* and *compose* in order to change a common subject into something unique. The camera isolates and frames, helping the viewer to select and compose. A fine photographer is as aware of art elements and design principles as any artist.

The quality of a photograph also depends on the *printing*. In making a finished photograph from a *negative*, the photographer uses several methods to achieve the desired results. *Cropping*—enlarging a central image or reducing surrounding space; *enlarging*—expanding the entire photographed image; and *exposing*—controlling the amount of light entering the camera lens are all methods used by the photographer to create photographic art.

The photographs shown on page 53 are examples of how photography becomes more than "picture-taking" in the hands of a skilled photographer/artist. These photographs offer a rich and varied range of moods and techniques. Notice how the photographers have made use of the art elements and design principles in each photograph. While "freezing" an image in time, these photographs are also composed in a way that adds mood, feeling, and a touch of mystery to the subjects recorded.

right. Gibbs Milliken. *Blue Wall with Trumpet Vine.* 1982. Color photograph, original print, 20" x 16". Collection of the artist. This photograph by Gibbs Milliken is from a series of photographs of walls. In this series his interest was on the design of shallow space.

123

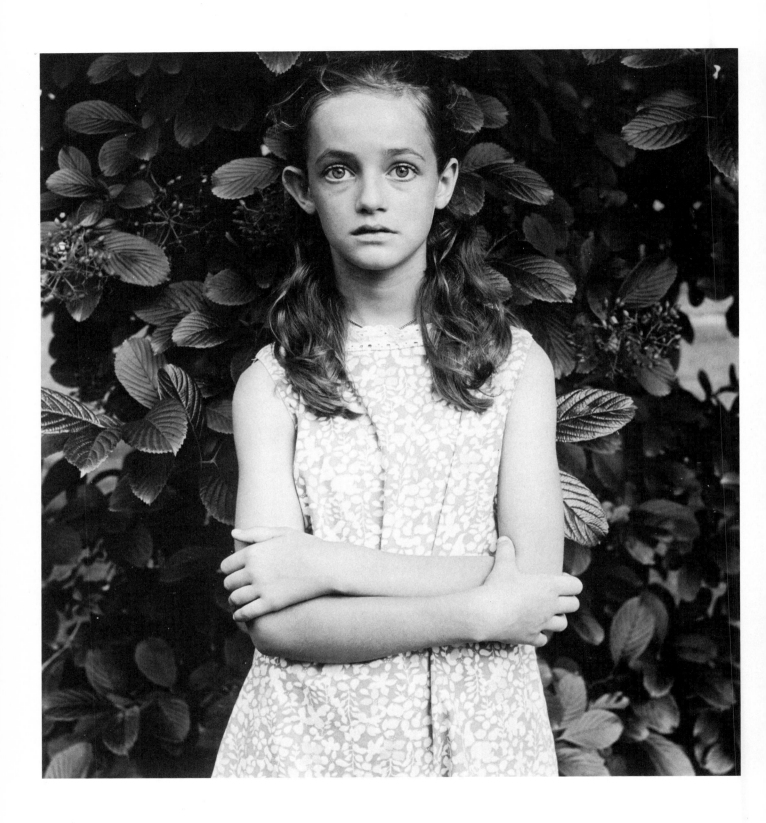

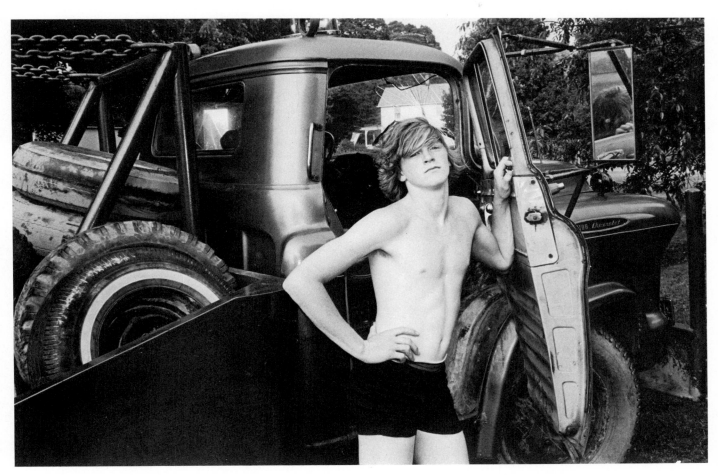

Mark Goodman. *Millerton, New York.* 1974. Black and white gelatin silver print, original print 14½" x 18¾". Collection of the artist. The two photographs here are from the photographic documentation of the coming of age of one generation of children in an average American small town. For this project Mark Goodman has taken over 1000 photographs. He started photographing in Millerton, New York, in 1971 and has continued to the present. left. Mark Goodman. *Millerton, New York.* 1971. Black and white gelatin silver print, original print 14" x 14". Collection of the artist.

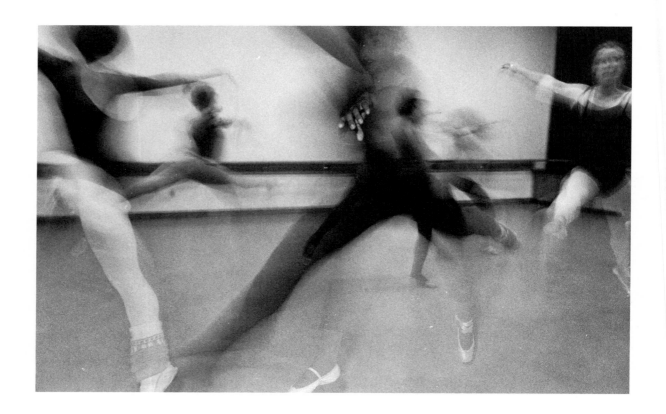

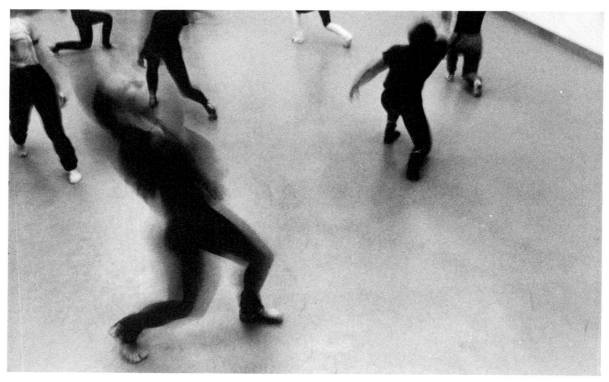

above. Ellen Wallenstein. *Dancers*. 1983. Black and white gelatin silver print, original print, 6" x 9". Collection of the artist.
below. Ellen Wallenstein. *Circles*. 1983. Black and white gelatin silver print, original print, 6" x 9". Collection of the artist.
During the years 1982-83, Ellen Wallenstein did a series of photographs showing dancers in motion. The two photographs above are part of that series. The photographer went into the dance studio during practice and rehearsals times to photograph.

126

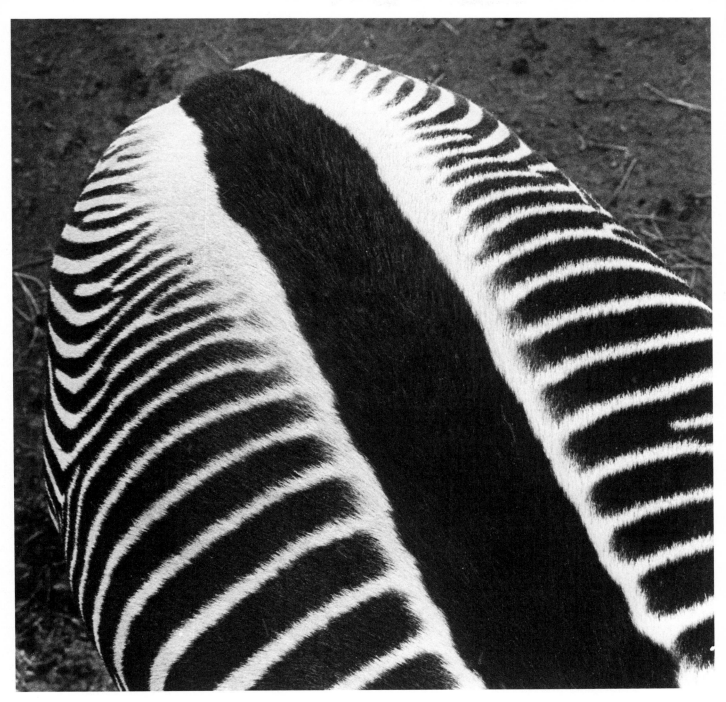

Hans Beacham. *Zebra*. 1985. Silver print, 6½" x 6½".

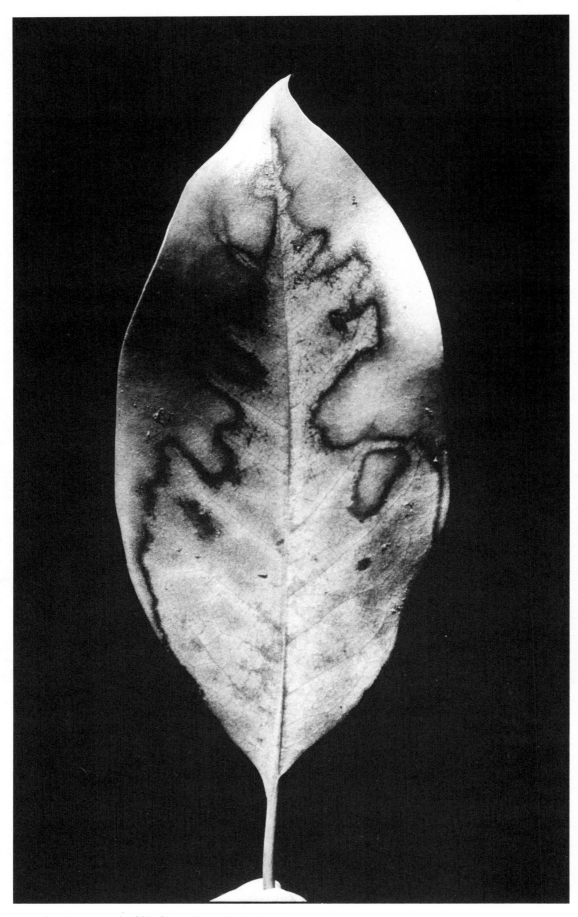

Hans Beacham. *Leaf.* 1985. Silver Print, 9⅜" x 5⅝".

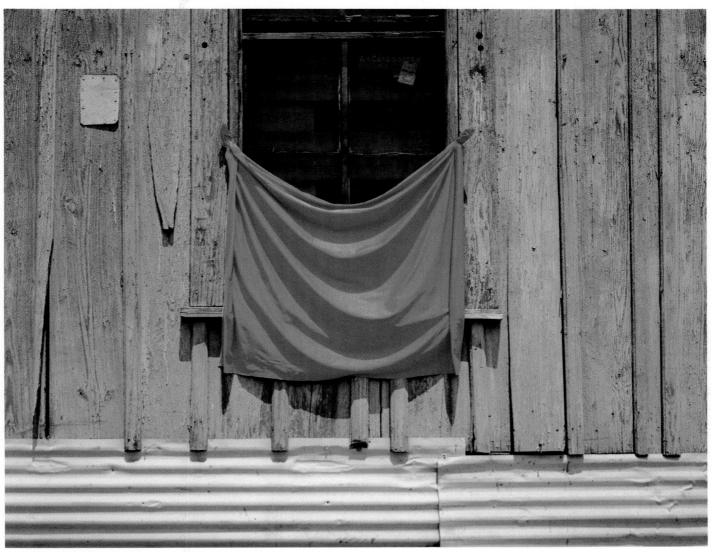

Photo by Gibbs Milliken.

Film and Video Production

Movies are probably the single most popular form of group entertainment in the world. Since their invention in the 1880's, films or "motion pictures" have had a tremendous influence on our lives. The art of the motion picture touches us in a special way by adding *motion* and *sound* to photographed images. In this way they come closer than any other creative form to convincing us of the reality and truth of the images they show.

While the production of most "visual" art involves only an individual artist, the creation of a major film requires the creative contributions of many people. Directors, actors, cameramen, set designers, and costumers all take a part. Of course, to use filmmaking as a creative tool does not necessarily mean that you need a budget of millions and a cast of thousands! Many students with the simplest of movie cameras and equipment are finding that film is just the right tool for their creative ideas.

Until a few years ago film was the only way to picture the world with motion. However, television and the invention of videotape, cameras, and recorders give artists other creative tools for making images move. In fact today many schools and individuals own video cameras and equipment. Check with your art teacher to see if film or video equipment is available for students' use.

A favorite form of filmmaking for many students is *animation.* This film technique is familiar to all of us through cartoons.

Caution:
Permanent markers and colored inks can stain clothes.

An animated film is made by creating a series of drawings, each slightly different from the one before. When filmed and run through a camera the drawings move. This method of filmmaking uses both drawing and painting techniques, as well as photography. Simple animated films are possible for students with little cost and equipment. In fact, an animated film can be made without using a camera at all. The drawings or dabs of color are made directly on the clear film itself like the samples on the opposite page. Permanent markers and colored inks can be used to make marks and dabs of color on the film. Make sure colors are transparent.

right. Drawing and painting on 16mm film.

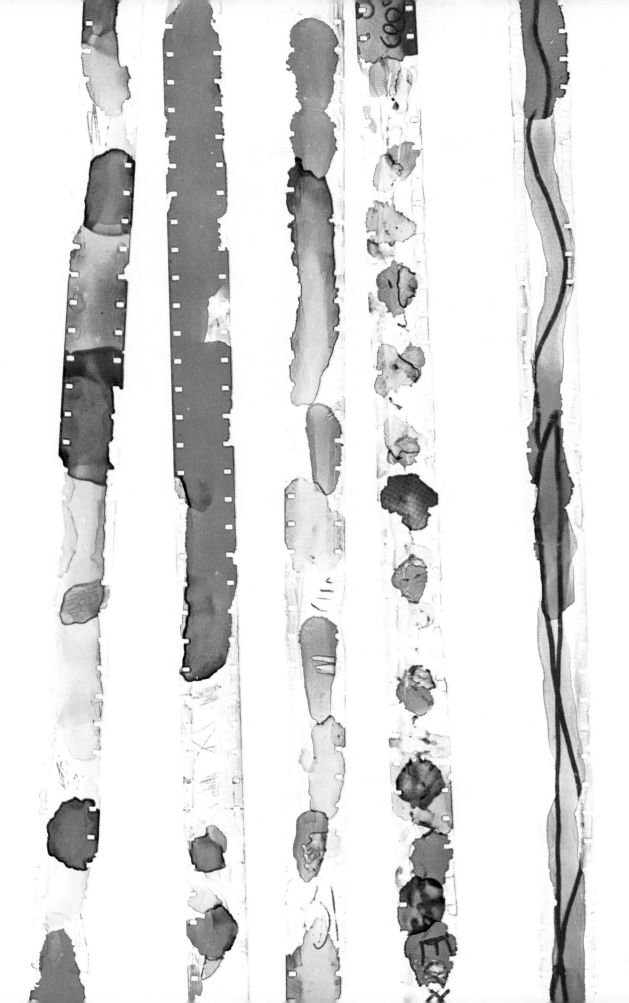

131

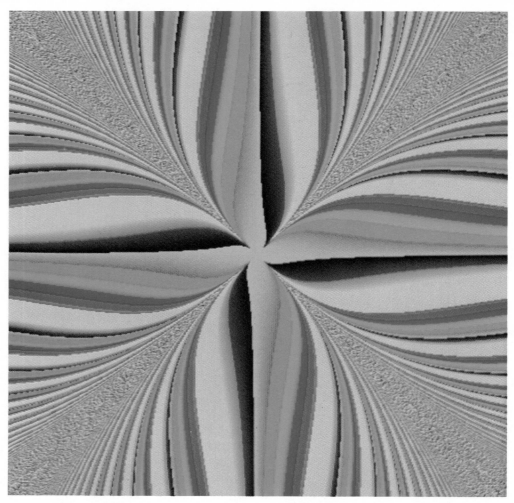

Symmetrical designs like the one above can be created with a computer by using a program producing a mirror image of part of the design. Credit: Dr. H. W. Franke and Horst Helbig — Peter Arnold, Inc.

Computer Art

What does the future hold for art equipment, materials and techniques? It is difficult to tell. New processes and tools for art expression are developed at an astounding rate each year. Indeed, artists of the future may use equipment never dreamed of as art tools. Remember, artists are inventive! They have a way of imagining and discovering new materials to express their ideas.

A perfect example of this fact is the newest art form — computer art. Of course, the computers do not create the art, the artist does. The computer is simply another art tool, like brush, pencil, or stone chisel. Who would have dreamed that computers, designed to organize and retrieve large amounts of information, would become "paint brushes"! Artists using computers can produce a still image like a painting or photograph, or an animated image like a movie. You have probably seen the amazing results of computer animation on television and at the movie theater. Many television commercials use computer animation to sell everything from jeans to hamburgers. If you are a fan of today's science fiction and fantasy movies, you have no doubt been dazzled by "special effects" created by computer. In fact, some visions of the future are possible only through computer animation.

What does the *distant* future hold for the creative artist? No one knows exactly, but it is sure to be a future filled with more exciting possibilities for expression through art. The artists of the future will use tools and materials never imagined by the great artists of the past. There may be computer animation in 3-D appearing in the middle of your living room. Lasers may take the place of pencils and brushes. The future for artists will be challenging and full of promise.

While our technology will continue to provide exciting and stimulating tools and materials for creating art, the most important element will remain the same—the artist. For true art is made *for* people *by* people.

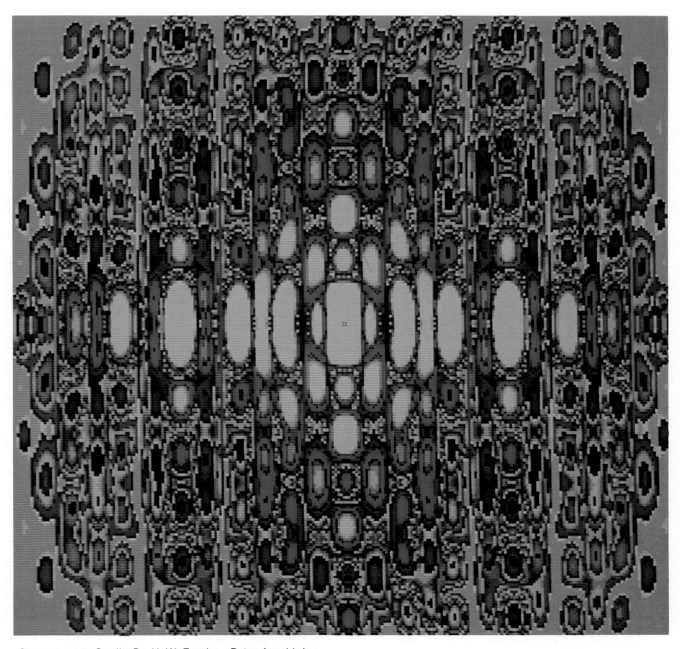

Computer art. Credit: Dr. H. W. Franke — Peter Arnold, Inc.

ARCHITECTURE AND TECHNOLOGY:
MAKE YOUR MARK!

1. Spend time looking at the architecture of your neighborhood or community. If you have a camera, take photographs of as many different architectural styles and types of buildings as possible. Compare the scale, design, and decoration. Make drawings of what you have observed in pencil or pen and ink. See if you can locate the "oldest" building in town and the "newest". Compare the two. How do they differ? What materials are used? Does the "newest" building borrow any details or decorations from the past?

2. Think about the design of your own house or apartment. Is it built on a "human" scale? Notice the size, number, and placement of windows and doors. Look at the floor plans of houses printed in newspapers and magazines. How does the architect indicate where doors, windows, and fireplaces are located? Design your own floor plan for a house or apartment. Add as many rooms as you need, but make sure each space has a reason for being included.

3. Using what you have learned about perspective, design and draw an example of monumental architecture. Your building may be for sport, government, religious, or transportation purposes. Consider, as you design, the ideal location for your structure. Refer to the examples of architecture shown on pages 111-120. Keep in mind the purpose or theme of your building. Can this theme be shown in the shape, position, or decoration of the building?

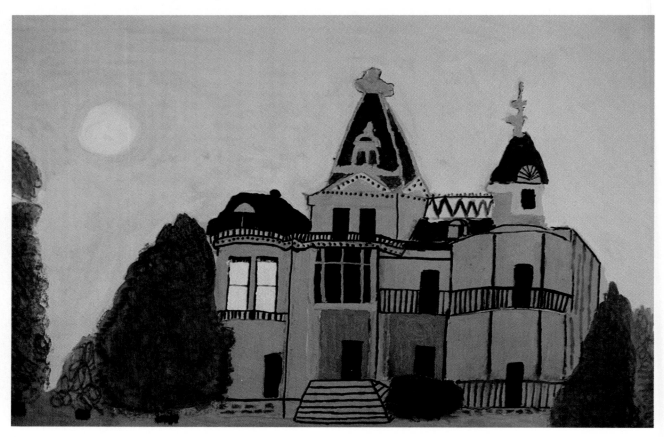

Student work.

4. If you own a camera, use it to photograph some part of your environment. Make several photographs of family members or friends. After you have the film developed, study your work. Do the photographs reveal anything about the subject beyond the image. Is there a mood or feeling in the pictures? Try to imagine how *cropping* and *enlarging* would alter the mood or feeling. Try cropping or cutting one of the pictures to change the composition.

Paraportian: Church. Contemporary structure. Mykonos, Greece. Photographed by student Erin Mayton.

5. If you have a slide projector at home or school you might try making slides without a camera. The process is simple and takes few materials. At a photographic supply store buy several cardboard slide mounts; they are inexpensive. Make sure you buy a size which will fit into your projector. The standard slide size is 35 millimeter. With clear acetate, or clear contact paper and your cardboard mounts, you can create some amazing images. Even the simplest drawings or objects take on a strange quality when projected on a wall or movie screen. Cut pieces of acetate or contact paper to a size which when folded in half will fit inside each mount. Your drawings or objects *must* be sandwiched between the folded pieces of acetate or contact paper. Use *transparent* drawing materials of any kind. Felt-tip markers, watercolor, colored acetate or tissue paper work well. Very small thin objects, such as leaves, shavings of plastic, thread or hair, can be pressed between the acetate to create interesting compositions. You might try making drawings or paintings from your slide collection. It will not be possible to make some of the images you create through experimentation in any other way.

6. Collect photographs from magazines which you feel were composed with art elements and design principles in mind. Glue each photograph to a sheet of paper. Under each photograph describe which art elements and design principles are most obvious. Was the photographer concerned primarily with *texture, color, value, unity,* or other elements and principles?

7. Without camera or projector you can create an animated film. One of the earliest ways to make images move was by using an instrument called a *zoetrope*. The drawings were placed inside a cylinder with slits cut in the top at regular intervals. When the viewer spun the cylinder rapidly and looked through the slots, the drawn images moved! Use the diagrams to construct your own zoetrope. Remember to keep your drawings simple. The smaller the movements between each drawing, the "smoother" the motion.

8. If you can obtain old 16 millimeter movie film you can make your own movie without a camera. Film, even with pictures on it, can be made clear by soaking the film in a bucket of bleach with a little water added. This process takes away the images, leaving clear film. *Caution should be used in bleaching the film.* Bleach can be dangerous if splashed in eyes, or if the fumes are breathed for a long time. The process of bleaching the film should be done under the supervision of an adult. Once the film is clear of images, you can draw with permanent felt-tip markers directly on the surface of the film. Individual pictures are difficult to use, since the film moves so fast through the projector that your drawing lasts less than a second! Try working with dots, blobs, scribbles and strokes of color. For something to project on the movie screen at all, it must be repeated at least 24 times for the eye to see it! Experiment with different images and materials. Film can be scratched and punched as well as drawn on to achieve some unusual effects.

How To Make A Zoetrope.

A

Cut posterboard circle 8 inches in diameter.

B

24″

3″

Cut strip of white drawing paper 24 inches long,
3 inches wide.

C

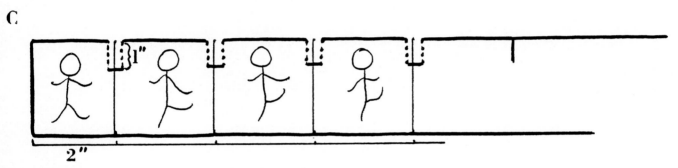

1″

2″

Mark off and cut slot every 2 inches. Make drawings between slots.

D

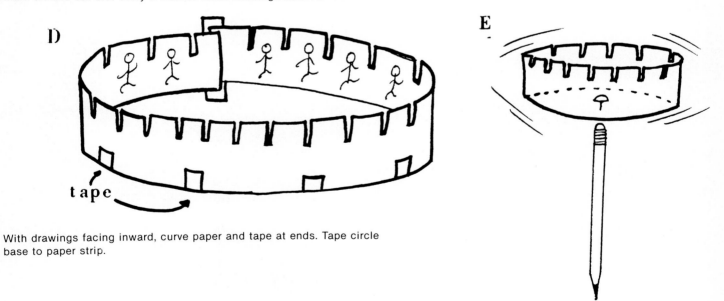

tape

With drawings facing inward, curve paper and tape at ends. Tape circle
base to paper strip.

E

Attach Zoetrope to pencil eraser with thumb tack.
Spin and look through the slots. Motion Pictures!

William Blake. *The Great Red Dragon and the Woman Clothed with the Sun.* c. 1797. Watercolor, 15¾" x 12¾". The National Gallery of Art, Washington, D.C., Rosenwald Collection.

CHAPTER V
LOOKING IN: FANTASY, MYSTERY, DREAMS, MYTHS

Throughout the ages, the invisible world of fantasy, mystery, dreams, and myths has provided artists ideas and inspiration. Even when a finished work reflects the reality of the visible world, the solutions to artistic problems have often come through the inner eye of the artist's imagination. In giving form to fantasies, artists suggest a world each of us has known, since each of us sleeps and dreams. Scientists tell us that everyone dreams. Artists find ways for remembering, drawing, and creating from their own dreams.

Although we live in a technological age, artists of the 20th century have explored the miraculous world of imagination and dreams just as extensively as did artists in the past. One such artist whose dreams and visions came to life was the 18th-century English poet-artist William Blake. One of the world's most gifted lyric poets, Blake was also a great painter of mystical experiences. Blake said he could look into the trees or at patterns in a piece of wood and find God. However, many people looked upon him as a mad dreamer, living in a world of imagined spirits and ghosts. Knowing this, it is easier to understand the highly imaginative figures we find in his drawings and paintings; the images seem to come from a supernatural world.

The Great Red Dragon and the Woman Clothed with the Sun, on the opposite page, is a watercolor. It is an illustration of Chapter 12 of the Book of Revelations from the Bible and depicts a vision of the righteous being raised above the powers of evil.

Another artist who used fantasy and symbols was Pieter Bruegel, a 16th-century Flemish artist. In his painting *The Temptation of St. Anthony* on pages 140-141 Bruegel has used supernatural and unrelated elements—flying people and animals, buildings which suggest creatures or objects, and eyes appearing from unexpected places. The scale is changed abruptly, creating a sense of surprise.

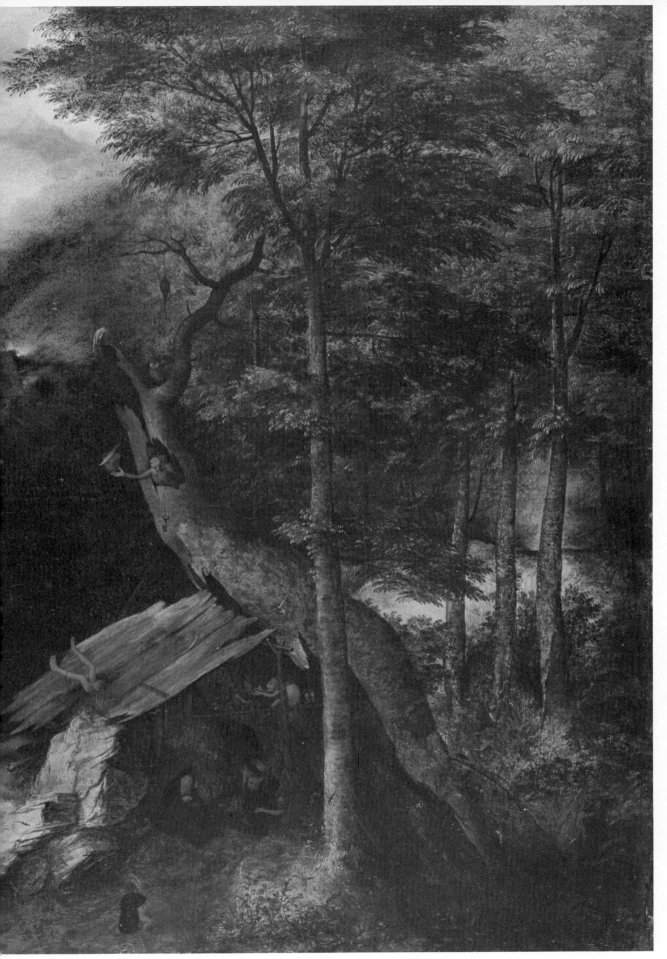

Pieter Bruegel, the Elder, follower of. *The Temptation of Saint Anthony*. Second half 16th century. Oil on wood, 23" x 33¾".
The National Gallery of Art, Washington D.C., Samuel H. Kress Collection.

141

Hieronymus Bosch, another 16th-century Flemish artist, used fantastic forms to portray the inner vision of his ideas. In *Death and the Miser*, Bosch filled a room with monsters, no doubt symbolic of death and eternal damnation, fears which gripped men's minds in the Middle Ages. The complete meaning of his works remains obscure.

Rejecting all traditional ideas about art, a group of artists in Zurich, Switzerland, in 1916 began a new art movement called *Dada*. The Dadaists selected ready-made and found objects such as bottle racks, mouse traps, bicycle wheels, theater tickets, and labels and assembled them into works of art. Kurt Schwitters, another artist of the original Dada group, assembled and painted *The Cherry Picture* in 1912. The Dadaists brought to the world of art a sense of nonsense, play and humor. Another example is Meret Oppenheim's *Object*, the fur covered cup, saucer and spoon, page 145.

The movement following Dada was *Surrealism*. Surrealism introduced ideas relating to the transferring of dreams and the unconscious to canvas. Both Bruegel and Bosch were forerunners of the 20th-century surrealist painters. Max Ernst, a Dadaist, introduced *frottage* (rubbings from textured surfaces) and *decalcomania* (the transfer of paint from one surface to another), producing fascinating shapes which could be developed into unrelated images and ideas. Centuries before, Leonardo da Vinci discovered similar fantasies and shapes in ink blotches and stains of color on weathered walls.

Max Ernst's painting, *The Eye of Silence*, on page 144 shows his original use of frottage and decalcomania, which he developed to the highest degree. These unusual and daring techniques opened up to the artist a new world of visual form.

Hieronymus Bosch. *Death and the Miser.* c. 1490. Oil on wood, 36⅝" x 12⅛". The National Gallery of Art, Washington, D.C., Samuel H. Kress Collection. right. Kurt Schwitters. *Cherry Picture.* 1921. Collage on painted cardboard, 36⅛" x 27¾". Collection, The Museum of Modern Art, New York. Mr. and Mrs. A. Atwater Kent, Jr. Fund.

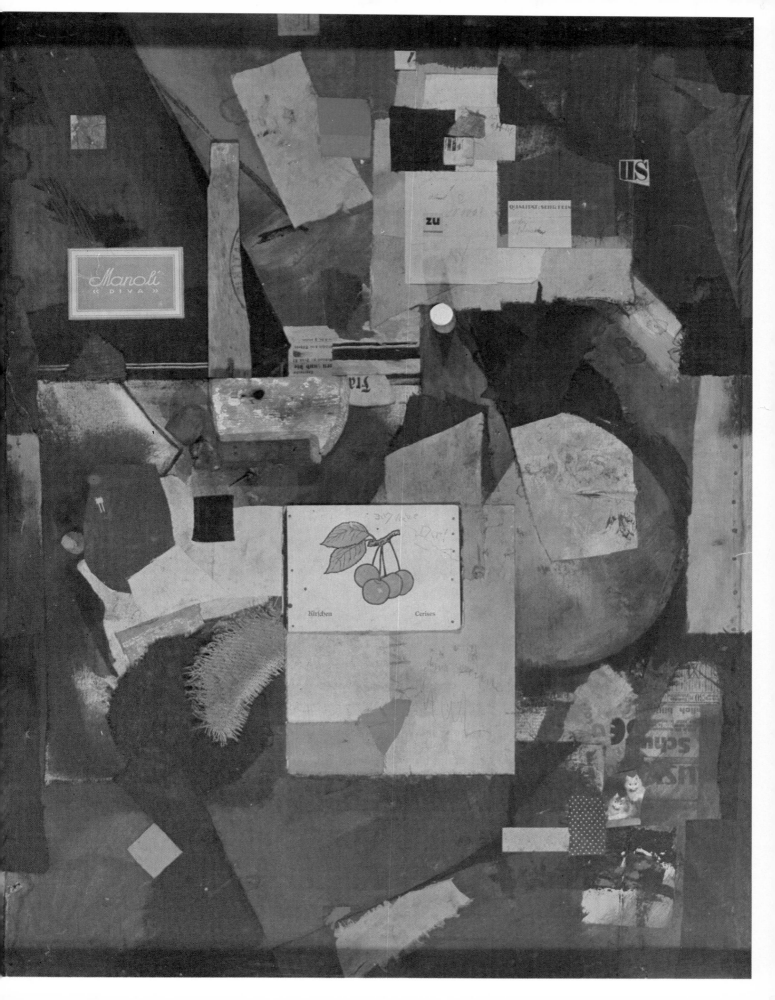

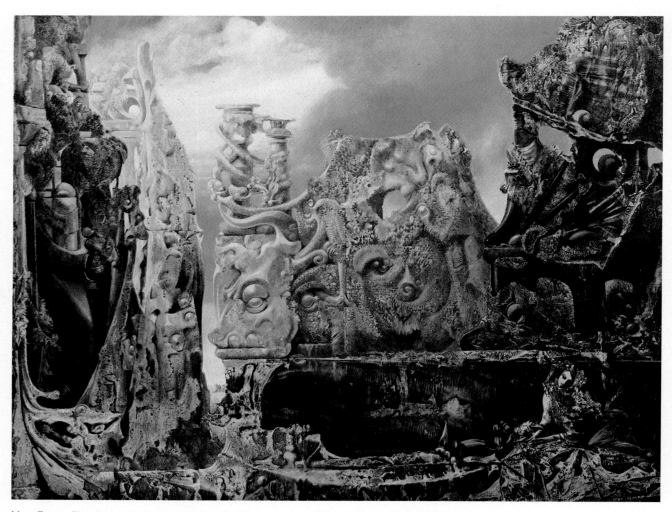

Max Ernst. *The Eye of Silence.* 1943-1944. Oil on canvas, 108 x 141 cm. Washington University Gallery of Art, St. Louis.

Salvador Dali, an early member of the Surrealist school, has called his paintings "Hand-Painted Dream Photographs." His famous *Persistence of Memory* is a haunting response to the vastness of space and infinity of time. Common objects, watches, are placed in an unusual setting and appear to be melting. Surrealists often choose to portray objects very realistically, but often in out-of-the-ordinary environments.

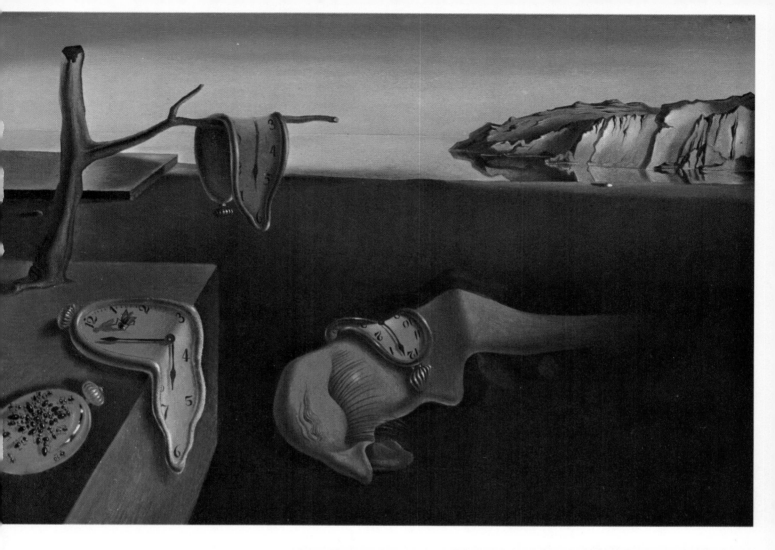

Salvador Dali. *The Persistence of Memory.*
1931. Oil on canvas, 9½" x 13". Collection,
The Museum of Modern Art, New York. Given
anonymously. right. Meret Oppenheim.
Object. 1936. Fur-covered cup, saucer, and
spoon, cup 4⅜" diameter, saucer 9⅜"
diameter, spoon 8" long: overall 2⅞" high.
Collection, Museum of Modern Art, New
York. Purchase.

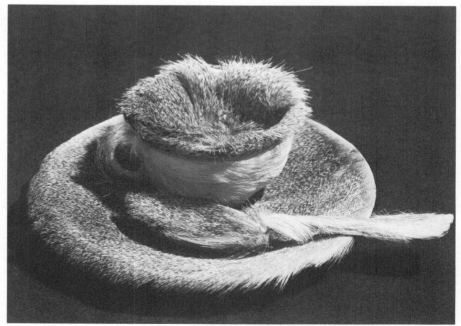

In Marc Chagall's dreamworld on canvas the impossible becomes possible. In *Paris Through the Window* figures float in space and objects take on colors and configurations known only in dreams and fantasy; there are animals, an upside-down train, the Eiffel Tower, and a double portrait. This vivid painting shows the influence of Cubism on Chagall's work.

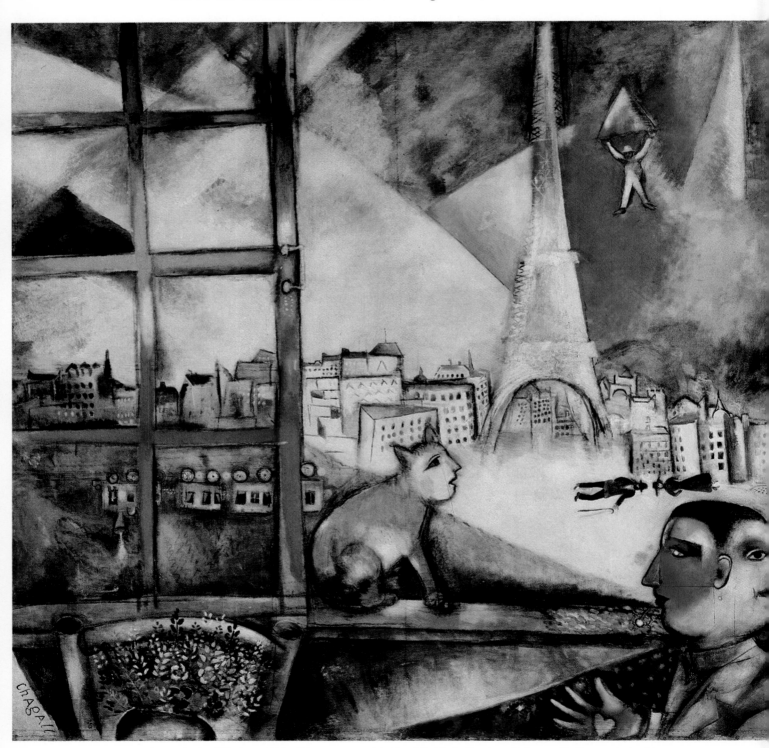

Marc Chagall. *Paris Through the Window.* 1913. Oil on canvas, 53½" x 55¾". Collection, Solomon R. Guggenheim Museum, New York. Photo: Carmelo Guadagno.

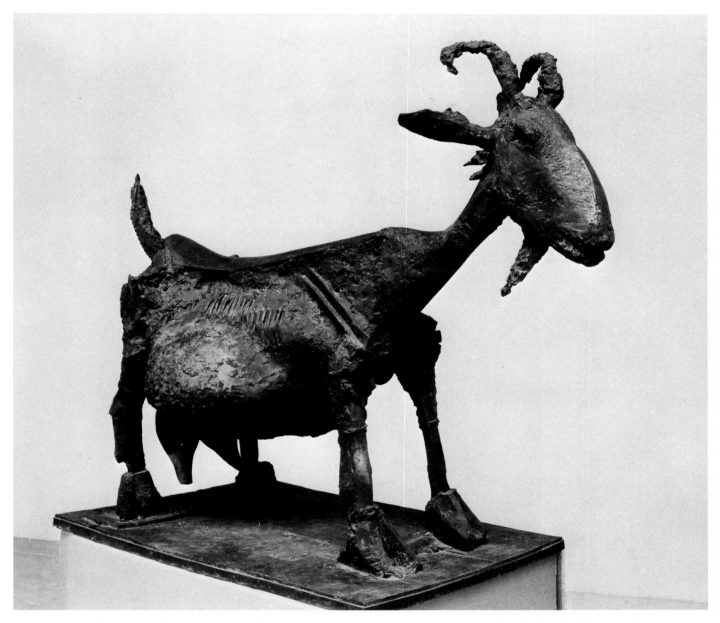

Pablo Picasso. *She-Goat*. 1950. Bronze (cast 1952), after found objects, 46⅜" x 56⅜", base 41⅛" x 28⅛". Collection, The Museum of Modern Art, New York. Mrs. Simon Guggenheim Fund.

Some artists of the mid-twentieth century revived Dada and utilized found objects to an even greater extend than did their predecessors. Pablo Picasso's *She Goat* expresses not only the artist's humor, but also the fun he must have had assembling found objects. Picasso combined the found objects with clay before casting them to create the various parts of the goat. Although parts of the body are in disproportion to others, the artist retained the goatlike characteristics within the sculpture.

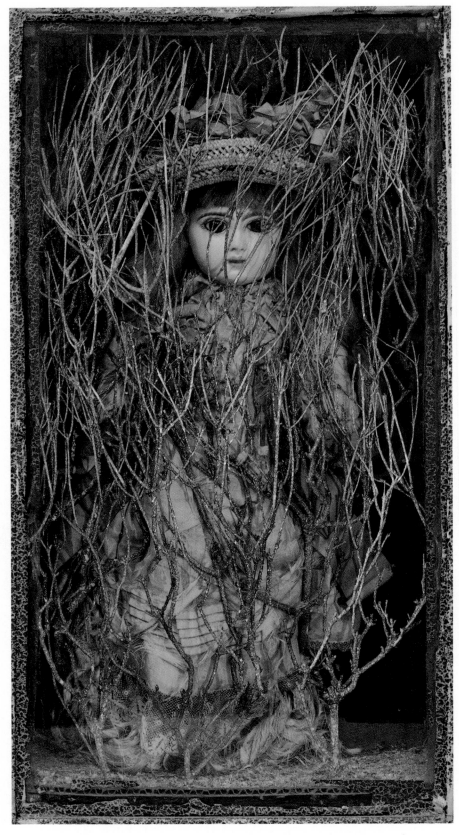

Joseph Cornell. *Untitled* (Bebe Marie). Early 1940's. Papered and painted cardboard box with glass front containing doll in cloth dress and straw hat with cloth flowers, dried flowers, twigs flecked with paint, 23½" x 12⅜" x 5¼". Collection, Museum of Modern Art, New York. Acquired through the Lillie P. Bliss bequest.

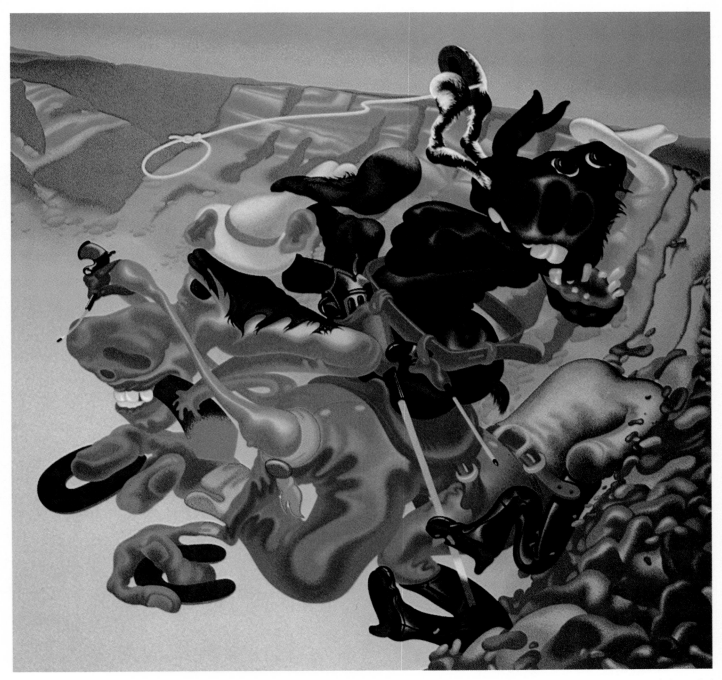

Peter Saul. *Cowboy*. 1983. Acrylic and oil on canvas, 79" x 81". Collection of the artist.

Fantasy, mystery, dreams, and myths continue to be sources of inspiration for many contemporary artists. Both Peter Saul and Luis Jimenez use the myths of the cowboy and the American West as subjects for their work. Rather than presenting a serious, realistic representation, both artists poke gentle fun at the cowboy and legends of the West.

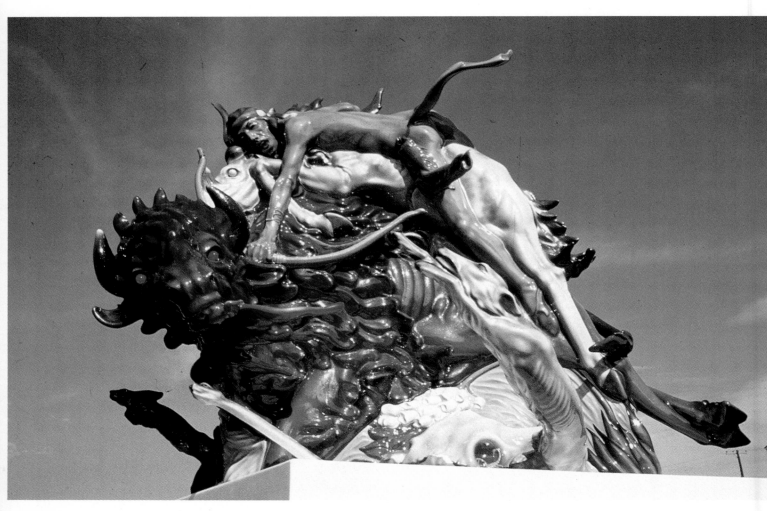

Luis Jimenez. *Progress I.* 1974. Fiberglass, 7'7" x 8'8" x 9'9". Private collection.

FANTASY, MYSTERY, DREAMS, MYTHS: MAKE YOUR MARK!

1. Imagine yourself encountering an unidentified flying object or U.F.O. Make a drawing or painting using felt-tip markers, pen and ink, or watercolors to illustrate your imagined encounter. Showing the "aliens" or spacecraft is not as important as finding a way to express your "feelings" and reaction to such a situation. Try to set the mood of such an experience by using what you know of color schemes and value.

2. Instead of telling about a dream with words, tell about it with art. Using a combination of materials—markers, crayons, photographs, paint—describe a dream you have had. Try to express in your art how you felt about the dream. In other words, was it pleasant or a nightmare?

3. Write a short story or poem about a new mythical hero or heroine. Your hero/heroine should be your *own* invention, *not* a copy of some known character like Superman or Wonderwoman. In your story or poem describe how and where your hero/heroine acquired special powers. Make a full color drawing or painting to accompany your story or poem.

4. Select a full-page, full-color photograph from a magazine. Divide the photograph into one- or two-inch parts. On a sheet of drawing paper reassemble the sections of the photographs to create a new design.

5. Look again at the work of Joseph Cornell on page 144. Create your own imagination box by collecting unusual objects, textures, and photographs. Assemble your collection inside a shoe, gift, or cigar box. Use paint, crayons, markers, and any other materials to complete your design. When you are finished, give your box a title.

6. Look at the work by Max Ernst on page 144. His work uses a technique called *decalcomania.* This is a monoprinting process using paint or printing ink. The artist applies wet paint to the surface of paper or canvas, then presses another piece of paper or plastic over the paint. Pulling the paper or plastic off leaves unusual textures and patterns in the paint. Experiment with decalcomania in your own work. Use it with other art materials to create a dreamlike landscape for a fantasy painting or drawing. Look for plants, animals, and faces in the textures and patterns of decalcomania.

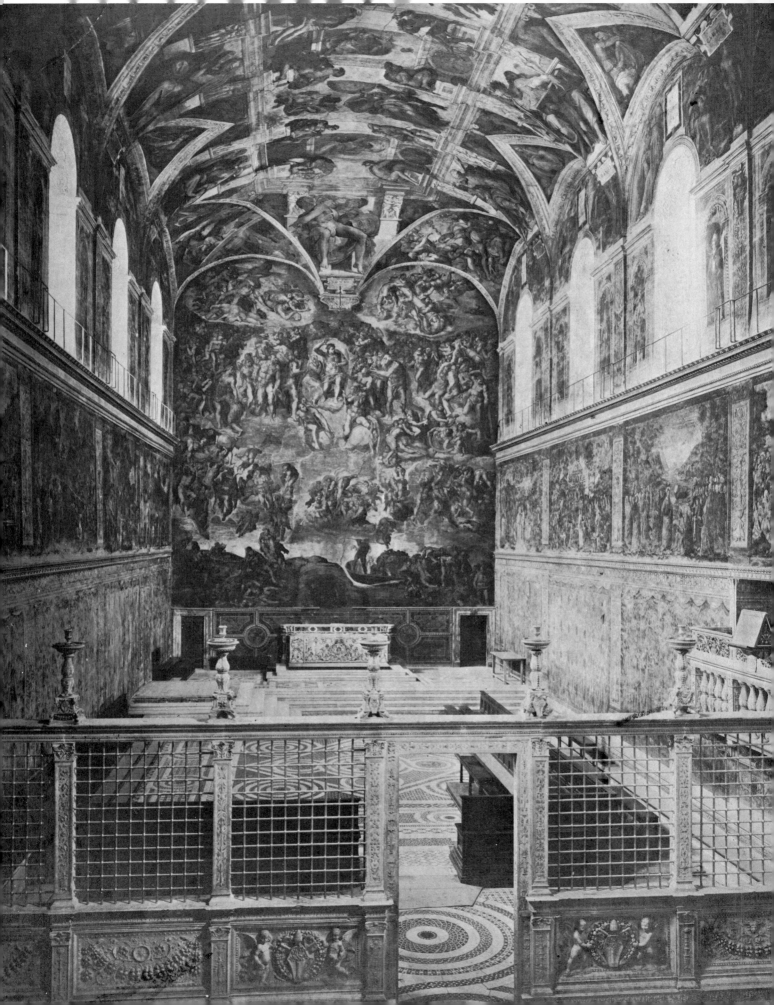

CAREERS IN THE VISUAL ARTS

In many ways art has been involved with the economic situation of every civilization. It was believed that making drawings of animals on the walls of caves brought good luck. They insured successful hunting of animals necessary for food and clothing. Figures were also carved from many materials to insure fertility, as well as to bury with the dead.

The skilled artisan was an important member of the Egyptian society, as is evidenced by the more than 5,000 beautifully-crafted objects found in one pharoah's tomb, that of King Tutankhaman. Red and black-figured vases were traded by the Greeks for things they themselves did not produce. Architectural monuments such as the Parthenon have yet to be equaled in simplicity of design and beauty.

As Christianity spread throughout Europe in the Middle Ages, cathedrals were built by hundreds of artisans (architects, stone cutters, sculptors, painters) who had been educated through the guild system; young apprentices studied and worked under others to become journeymen or even guild masters.

Artists have been hired throughout the ages to express the spiritual ideas of people, as well as to reinforce the social and economic status of the nobility. Famous "commercial artists" of the past include Phidias, Giotto, Leonardo da Vinci, Michelangelo, El Greco, Rubens, Rembrandt, Velazquez, Goya, and many others; government officials, religious leaders, and wealthy citizens commissioned works by these and other artists.

left. Michelangelo. *The Last Judgment and Ceiling Fresco.* The Sistine Chapel, The Vatican, Rome. Photo: The Bettmann Archive.

Today, many major businesses and governments commission works and support the visual arts because they believe art improves our quality of life, leading to greater productivity and improved morale of their employees. Also, because the visual images created by artists can have such persuasive powers on the public, businesses hire graphic designers to assist them in establishing identities which are known the world over—the golden arches, Coca-Cola in red script, IBM, 3M, KODAK, Nike, ATARI, Cabbage Patch Kids. Visual images associated with specific products and services contribute greatly to their financial success.

Architects and craftsmen are needed to design and enhance our homes, public buildings, offices and parks. Every utensil, tool, toy, computer, piece of furniture, and automobile has to be designed by someone. Medical journals must have accurate illustrations. Photographers, television cameramen, and filmmakers are in great demand. No longer must you be a painter or sculptor in order to have a career in the visual arts.

While exploring and experimenting with a variety of art media, you may decide to consider a career in the visual arts. You are presently learning to use the art elements, design principles, and art techniques which are basic skills in many art-related jobs. Currently there are more than 200 careers and occupations which relate to the visual arts. The careers which follow are listed in sixteen categories.

ADVERTISING

graphic designer
art director
layout artist
illustrator
paste-up artist
display artist
package designer
calligrapher
type designer
window decorator
researcher
photo retoucher
sign painter
color consultant
photographer
publicity director
printer
advertising agency director

ARCHITECTURE

architect
city planner
model maker
lighting consultant
landscape architect

draftsman
architectural illustrator
painter
paper hanger
stained-glass designer
woodworker

BUSINESS AND INDUSTRY

graphic designer
art director
industrial designer
design consultant
industrial photographer
body stylist
interior stylist
body repairer
pin striper
textile designer
color consultant
market researcher
foundry artist
package designer
designer in paper/glass
design engineer
model maker
sign painter

framer
exhibition/display designer
product designer
toy designer
florist
gift wrapper
trophy designer
uniform designer
jeweler
lighting consultant
lithographer
window trimmer
tool designer
buyer
mock-up artist
renderer
chef
pastry decorator

CINEMATOGRAPHY

cinematographer
photographer
animator
background artist
set designer
art director

makeup artist
cameraman
special effects artist
director
choreographer
wardrobe designer
properties artist
cutter and editor

CRAFTS

ceramist/potter
jeweler/silversmith/goldsmith
enamelist
weaver
leather craftsman
metalworker
cabinet maker
stained-glass designer
glass blower
wood-carver
serigrapher
calligrapher

CRIMINOLOGY

police artist
courtroom artist
police and legal photographer

EDUCATION

elementary teacher
art teacher
instructor
professor
art consultant
art therapist
crafts counselor
textbook author
art historian
art lecturer
artist-in-residence
researcher
industrial arts teacher
art reference librarian

FASHION

hair stylist
fashion illustrator
fashion editor
fabric designer
makeup artist
fashion photographer
jewelry designer
fashion commentator
accessories designer
color consultant
window decorator
buyer
dressmaker

FINE ARTS

painter
sculptor
printmaker
photographer
filmmaker
portraitist
muralist

GALLERIES

gallery director
curator
art librarian
restorer
researcher
guide
lecturer
gallery owner
art dealer
artists' agent
salesperson
display artist
art auctioneer

INTERIOR DESIGN

interior designer
decorating studio assistant
furniture designer
antique restorer
illustrator
color consultant
lighting consultant
fabric consultant
draftsman
model maker
upholsterer

JOURNALISM AND PUBLISHING

art editor
art critic
art publisher
illustrator
layout artist
cartoonist
comicstrip creator
photography editor
political cartoonist
lithographer
photographer
graphic designer
calligrapher
greeting card designer
type designer
caricaturist
photo-retoucher
papermaker
bookbinder
book jacket designer

record cover designer
author

MILITARY

cartographer
combat photographer
combat artist
illustrator
training aids artist
draftsman
sign painter
aerial photographer
functional designer

PHOTOGRAPHY

scientific photographer
portrait photographer
photo journalist
commercial photographer
industrial photographer
dark room technician
news photographer
fashion photographer

SCIENCE AND MUSEUMS

museum educator
curator
technical illustrator
medical illustrator
scientific photographer
display artist
diorama artist
cartographer
researcher
field expedition artist
marine illustrator
museum director
exhibition designer
restorer
conservator
model maker
catalog designer

THEATER, OPERA, TELEVISION, DANCE

publicity designer
program designer
scenic designer
set builder
costume designer
lighting consultant
make-up artist
choreographer
animator-TV
graphic artist
background artist-TV
director
puppetmaker
puppeteer

Abstract art. A visual expression of the *essence of a subject as interpreted by the artist, rather than a representation of its natural* appearance.

Aesthetic. Having to do with what is beautiful in art and nature.

Analogous. Colors next to each other on the color wheel, such as red, red-orange, and orange.

Applique. Stitching one material on top of another for decorative purposes.

Aquatint. An etching process in which the ground is prepared. When the plate is heated, the melted particles adhere, leaving minute openings throughout. Varying degrees of dark and light are produced by timed biting of acid. They are controlled on the plate by painting out areas after each biting.

Armature. The foundation that gives support and shape to various kinds of materials used to create a sculptural form.

Art elements. Components or ingredients used by artists to express ideas—line, color, texture, shape/form, value, and space.

Art principles. Rules used by artists to arrange the art elements into a work of art—unity, balance, variety, emphasis, movement/rhythm, repetition, contrast, and proportion.

Assemblage. Found objects assembled into a structural form of sculpture or a kind of relief collage.

Asymmetric. Balance within a composition based on an *informal* relationship rather than on a symmetrical (perfectly balanced) arrangement.

Background. The area *behind* the objects, shapes, and textures of a composition.

Balance. Formal: Parts of a composition are the same or equal on both sides.

Balance. Informal: Parts give the feeling of balance, but if the composition is divided in half, one side is not identical to the other.

Balsa. A soft, lightweight wood used for carving, model building, and sculptural and architectural forms; usually comes in blocks, sheets, and strips.

Bas-relief, or low relief. A sculptural form in which portions of the design protrude slightly from the background.

Bat. A flat plaster slab used to support clay while modeling is in progress, and for storing the clay piece until the next work period.

Batik. A technique of creating patterns on cloth by applying hot wax on some areas of the cloth and then dyeing the cloth another color. When the wax is removed, the original cloth color remains where wax has been.

Bisque. The condition of clay when it has been fired but not glazed.

Brayer. A roller for applying and spreading ink.

Burnisher. A spoon or other smooth, rounded tool used for rubbing the back of paper while on the block to aid the absorption of ink and create the print.

Casting. Forming a slab or other object by pouring a mixture, such as plaster of paris and water, into a container or mold and allowing it to become solid.

Ceramics. Objects made of clay.

Coiling. A method of building ceramics by using pieces of clay which have been rolled into long snakelike strips.

Collage. A design or picture developed by fastening paper, cardboard, or other materials to a supporting background.

Complementary colors. Sharply contrasting colors opposite each other on the color wheel—yellow/purple, red/green, blue/orange.

Composition. The arrangement of lines, colors, textures, and shapes within a larger shape such as a square, rectangle, or circle to create rhythm, repetition, movement, and balance.

Contour. The outline of objects or shapes.

Contrast. Sharp differences in lines, colors, values, shapes, forms, and textures.

Crayon resist. Drawing made with wax crayon and covered with a wash.

Crosshatching. The drawing of lines close together in opposite directions to create dark areas in a drawing or print.

Design. The organization of lines, shapes, colors, textures, and mass within another shape to create an aesthetic arrangement.

Distortion. An artist's deliberate or intuitive change of natural shapes, forms, colors, textures, for aesthetic purposes.

Dowel. A small wooden rod which comes in a variety of lengths and diameters.

Drypoint. This technique is usually executed on copper plates with needlelike instruments. With this tool the artist scratches across the surface of the plate and a burr, or curl of metal, is left along the edge of the scratched lines. In inking, the

burr catches the ink in such a way that the printed image has a velvety appearance. The printing process is very much like that of engraving. No acid or ground is necessary for doing a drypoint. After the drawing is scratched in, the plate is inked, wiped, and printed.

Emphasis. Dominance within a work of art; focal point.

Engobe. A clay slip, white or colored, applied to a ceramic piece either when the object is leather-hard or at the bisque stage, as a form of decoration.

Engraving. The process of incising or cutting lines into metal or other surfaces. In printmaking, using a burin on a copper plate, a channel is cut that holds the ink after the plate is wiped clean. This is the first step in the process of engraving. There is a crisp quality to the lines created in metal engraving. Much skill is required of the artist, yet his individuality is evident in the way he manipulates the engraving tools.

Etching. Etching is the process of biting with acid through a ground covering the plate, resulting in several kinds of "etched" lines, darks and lights, and textures. Hard-ground etching is done by drawing and scratching with an etching needle through a thick hard ground of dried liquid asphaltum. Afterward, the plate is placed in an acid bath for biting. The asphaltum on the plate resists acid. The scratched lines exposing the metal are etched by the acid. They will receive and hold the ink. Rich blacks result from proper wiping and printing.

Expression. An artist's subjective and creative response to objects and events.

Fired. Condition of the clay piece after it has been hardened by exposure to the high temperature of a kiln.

Focal point. The special spot or area within a composition where the observer's eye concentrates its attention.

Form. A three-dimensional shape which can be felt and viewed from all sides.

Found objects. All kinds of materials that are found naturally and combined to create two- or three-dimensional works of art.

Frottage. Using a drawing tool to transfer textures and tones onto paper which has been placed over a textured surface; drawing images while rubbing.

Glaze. A mixture of finely-ground materials that melts at high temperatures to form a thick, permanent, glossy or mat coating on a piece of ceramics.

Greenware. Condition of the air-dried clay piece before it is fired.

Grog. Ground pieces of ceramic clay which has been fired; it is added to plain unfired clay for extra strength.

Grout. Fine cement or plaster used to fill the space between tesserae in a mosaic.

Harmony. The arrangement of elements of a composition in a way that creates a feeling of unity pleasing to the eye.

Heddle. A movable part of a loom which lifts some of the warp threads to create a *shed.*

Horizon line. An imaginary line in a perspective drawing where the earth and sky seem to meet; it is usually on the eye level of the observer.

Icon. An image: representation or symbol.

Impasto. The application of thick layers of pigments.

Impression. The printed image produced by an inked block or plate.

Incising. Cutting or carving a line on the flat surface of a material with a knife.

India ink. A permanent black drawing ink.

Inking plate. Glass, or other nonabsorbent surface, on which ink is rolled with a brayer for applying to a printing block or plate.

Intaglio. The process of cutting or etching an image into a plate, usually zinc or copper. The recessed lines hold the ink and make the impression on damp paper when pressure is applied.

Intensity. The brightness or dullness of color.

Kiln. An oven or furnace used for drying, firing, and glazing ceramics and for enameling metal.

Kiln furniture. The shelves, shelf supports, and stilts which support the bisque and glazed pieces during the firing.

Kiln wash. A specially prepared substance brushed on the shelves and floor of the kiln, to protect surfaces during glaze firing.

Leather-hard. The condition of the clay piece when it is firm enough to hold its shape but still slightly moist.

Line. Any mark, longer than a point, made on a surface.

Linear perspective. The effect achieved by drawing lines on a flat surface which create an illusion of three-dimensional objects and space.

Lithography. A printing process involving the use of a smooth limestone block or slab. The drawing is done with a grease crayon. The stone is then treated with gum arabic and nitric acid and dried. The grease is removed with solvent. The stone is wet and inked to "bring up" the image. The stone is again "etched" with gum and acid and dried. The ink and gum are removed. The stone is again wet and inked; paper is placed on the stone and it is passed through a lithograph press. Lithography is based on the principle that water and grease do not mix—that the wet areas of the stone will not accept the ink.

Loom. Supporting framework for warp threads in weaving.

Mass. A form or area of color or value.

Matboard. A heavy poster board for mounting art work or cutting to form a mat for prints.

Medium. The materials used by an artist, such as: pencil, charcoal, tempera paint, ink, etc.

Mezzotint. Using a tool known as a mezzotint rocker, the artist covers a metal plate with a surface of burrs. This effect is achieved by rocking the tool from side to side as its teeth dig into the plate. When it is finally covered with a ground of burrs, areas are removed in varying degrees, from dark to pure white, with scrapers and burnishers. The plate is inked and wiped clean before printing.

Monochromatic. Consisting of *one* color with various shades and tints of the color, such as pure, light, dark, bright and dull blue.

Monoprint. A one-of-a-kind print created by transferring to paper a design made with ink or paint on a hard surface by rubbing the back of the paper.

Mosaic. A surface decoration made by inlaying small pieces, *tesserae*, of material to form pictures or patterns.

Motif. A recurring feature of a design or decoration.

Movement. Actual motion or the illusion of motion; repetition of elements which allows the eye to move throughout a composition.

Mural. A painting or collage applied to a wall surface.

Negative space. The space *between* objects, such as the empty areas between leaves on a branch.

Nonobjective art. A form of art expression in which the organization of the elements of design bear no resemblance to natural objects or the real world.

Papier-mâché. Paper pulp mixed with paste to form a modeling material or paper strips saturated with paste which provide a means of shaping three-dimensional forms.

Pattern. The repetition of shapes in a design, such as the repeated lines of a zebra.

Pigment. The ingredient that gives color to paint or ink.

Plaster of paris. A white powder made of gypsum which, when mixed with water, forms a quick-setting paste; useful in casting and construction.

Portrait. Any form of art expression which resembles a specific person.

Primary colors. Red, blue, and yellow.

Proof. A trial print.

Proportion. The relation of one object to another with respect to size, amount, number or degree.

Pyrometer. An instrument which indicates the heat in a kiln.

Repetition. Use of an element more than once.

Resist. A technique of designing with wax to resist or repel the application of water-soluble inks, paints, and dyes.

Rhythm. The repetition of design elements in a systematic way which allows easy movement of the eye throughout the composition.

Rya. A technique of attaching yarn to warp threads; when placed close together and cut, it gives the textural effect of pile to handwoven fabrics, rugs, and hangings.

Scoring. Making a crease in paper or lightweight cardboard with a dull instrument to aid in bending or folding. This term also applies to scratches made on clay for welding two pieces together.

Secondary colors. Colors created by mixing red and yellow to make *orange*; blue and yellow to make *green*; blue and red to make *purple*.

Self-portrait. An image of oneself.

Selvedge. The edge of woven fabric.

Serigraph. A silk-screen print.

Sgraffito. This Italian word means "scratch through". Sgraffito decoration is

scratched through the top layer of colored slip before firing, allowing a contrasting clay color to show through.

Shed. The separation of warp threads which allow passage of weft threads in weaving.

Shuttle. The weaver's thread holder that leads the weft thread in and out through the warp.

Skein. A loosely-wound measure of yarn.

Silhouette. The *outline* of an object.

Silk screen. A stencil process in which ink or paint is forced through open meshes of a silk screen that has been prepared with a stencil, blocking out nonprinting areas.

Slab. Clay that has been rolled out to form a sheet of even thickness.

Slip. Clay thinned with water to form a thick liquid and used over scored areas to join pieces of clay together.

Soft-Ground Etching. The printmaking technique employing a soft ground that does not harden by resisting an acid bath. Any texture deliberately pressed into the ground leaves its impression. Thus, many textures are possible.

Space: two-dimensional. Art work occupying space which has length and height and is more or less flat.

Space: three-dimensional. Art work which occupies space which has depth, or thickness, as well as length and height, such as sculpture.

Stilts. Small pointed clay pieces placed under clay objects to keep them from sticking to the shelf of the kiln when glaze firing.

Structural forms. Forms made of materials put together by adhering, nailing, casting, interlocking, or some other method of constructing a work of art.

Symmetrical. The state in which each half of a design, object, or arrangement is identical to the other half.

Tactile. The feeling experienced from the sense of touch.

Tapestry. Weaving in which a design is created by weaving the weft thread only part of the way across the width of the fabric.

Tjap. A metal hand stamp used by batik artists to apply wax, repeating designs on fabric.

Tjanting tool. A hand tool used to hold hot wax for creating linear designs on batiks.

Tempera. A common waterbase paint in which egg or some other glue binds the color pigments together.

Tesserae. Small pieces of glass, tile, stone, paper, or other materials used to make a mosaic.

Texture. The way a surface *feels* to the sense of touch or how it may *appear* to the sense of sight; actual or visual representation of an object's surface.

Three-dimensional. Any object which has depth, height, and width.

Tint. Any color to which white has been added; for example, pink is a tint of red.

Tone. Darks and lights in a work of art. Also color quality or value.

Translucent. Transmitting diffused light so objects beyond cannot be clearly seen.

Two-dimensional. Any object which has only width and height.

Unity. The totality of related parts creating a feeling of wholeness or harmony; parts fit together.

Value. The lightness or darkness of color; the gradation of light grays to black.

Vanishing point. The place (or places) where all straight lines converge in a perspective drawing.

Variety. Different lines, colors, values, shapes, forms, and textures.

Vermiculite. Granules of mica used for insulation purposes, often combined with plaster or cement to form a soft, lightweight carving block.

Warp. The taut thread that supports the weft thread and runs the length of the fabric in weaving.

Wash. A color which has been thinned with water (or turpentine, if the paint is oil) so that when it is brushed on the paper, canvas, or board, the surface beneath can still be seen.

Wedging. Pounding and kneading clay to remove air pockets, thus preparing it for use.

Weft. The thread or other material that goes across the warp from side to side in weaving.

Woodcut. A type of relief printing in which areas of the wood block are chiseled away; the remaining surface receives the ink and is printed onto paper when pressure is applied.

INDEX

INDEX OF ARTISTS

ACKNOWLEDGEMENT

The authors wish to thank the following people who were helpful in the completion of this book:
Hans Beacham, Photographer, Austin, Texas; Dr. Jeannette J. Varner, Editor, Austin, Texas; Elaine Burden, Round Rock, Texas.